How To
Photograph
Birds

How To Photograph Birds

Larry West
with Julie Ridl

STACKPOLE
BOOKS

Published by
STACKPOLE BOOKS
Cameron and Kelker Streets
P.O. Box 1831
Harrisburg PA 17105

Printed in Singapore

First Edition

10 9 8 7 6 5 4 3 2

Published in Canada by special arrangement with Meridian Press,
50 Main Street, Ottawa, Ontario K1S 1B2. ISBN 1-895771-01-3.

Cover design by Tracy Patterson with Mark Olszewski

Library of Congress Cataloging-in-Publication Data

West, Larry.
 How to photograph birds / Larry West with Julie Ridl. — 1st ed.
 p. cm.
 Includes bibliographical references and index.
 ISBN 0-8117-3013-1
 1. Photography of birds. I. Ridl, Julie. II. Title.
TR729.B5W47 1993
 778.9'32—dc20 92-28803
 CIP

For Puff and Maybe,
who love birds easily as much as we do.

For Bonnie and Jack.

And for Betty Darling Cottrille,
whose love and knowledge of birds inspire us and
whose remarkable spirit remains with us.

C O N T E N T S

Preface . ix

Part I: A New Phenomenon and a
New Approach . 1
 Art through Technology 3
 What Is It with Birds? 4
 The Light Side and the Dark Side 7

Part II: The Equipment 8
 Cameras . 8
 Lenses . 15
 Support . 26
 Film . 32
 Remotes . 34

About Birds: A Larry West Portfolio 35

Part III: Photographics 58
 Exposure . 58
 Light and Flash 69

Part IV: Photographing Birds 78
 Low-impact Photography 78
 Getting Close 83
 Nesting Birds . 95
 Packing for Fieldwork 99
 Photographing Flight 99

Part V: Making a Good Photo Great 104
 Learning to See 104
 Knowing Your Subject 104
 The Decisive Moment 106
 Recording "Suchness" 109
 Composition Primer 110

Afterword . 111
Resources . 112
Bibliography . 114

. . . bird by bird I've come to know the earth . . .

—Pablo Neruda,
"The Poet Says Good-bye
to the Birds"

PREFACE

In 1987, almost as soon as Larry West and I began cowriting, we started fiddling with the idea of one day making beautiful books together, each of us convincing the other that a collaboration made sense. Larry had more than thirty years of experience as a nature photographer and teacher. I had no experience photographing nature but plenty of experience writing and editing—organizing information. In doing articles together we determined that if a complete novice like me could understand Larry's technique well enough to write about it, then anyone could understand it. We thought the idea would easily transfer to book writing.

Before we met, Larry had been making and publishing photographs and teaching photography workshops for many years, so long that he'd seen many of his students go on to achieve great success making and marketing their nature photographs—some of them becoming successful teachers themselves. His students begged, poked, and encouraged him to publish. But the right time never seemed to present itself.

I had been writing nonfiction in the mainstream and nature press when I accepted the position of managing editor of *Birder's World* magazine. During my years with the magazine, I was lucky enough to interview and profile some of the country's leading nature photographers. I found the artists themselves easily as interesting as the subjects they photographed. So when I left the magazine to concentrate on my writing, the book idea resurfaced with a vengeance.

And the time seemed right: The technical syntax of photography had changed enough that the market needed new introductory texts. The growing number of hobbyist nature photographers demands a text that models a low-impact approach to nature photography— an approach Larry began advocating long before "low-impact" hit the national vocabulary. The growing number of birders in the field suggested that the first of our texts concentrate on *bird* photography. And Larry's community of long-time students threatened both of us with bodily harm if we didn't get on with it soon.

So we drew up an outline, gathered our past writing, and sent it to Stackpole Books. We'd admired their work, dreamed of books produced on beautiful paper with rich, vivid photographic reproductions. We kept our fingers crossed.

Stackpole's Judith Schnell agreed it was time for a nature photography title. She assigned the very able John Cominsky to look after us. And we sat down and made a book.

What you hold in your hands is the result of our efforts to bundle Larry's bird photography workshop into one neat package. If the book seems to have a split personality, it is by design. The workshops present two kinds of information: the straight-on technical know-how and the vicarious "you were there" segments, during which Larry launches into a storytelling mode, relaying the particular challenges or

concerns behind many of his own photographs. "About Birds: A Larry West Portfolio" is designed to get at this "armchair photographer" experience, and as in the workshops, we've sandwiched it between the chapters of photography know-how.

Of course, an explanation of photography cannot be presented in truly sequential steps, because many technical and artistic decisions and actions must be made at once to record a good photograph. Because each decision affects the others, understanding must be complete at the outset. That logic ruled our deci-

sion to present the sections of the book as we did, placing equipment first and following it with photographics, help in approaching birds, and finally compositional notes. We aimed to smooth our readers' way by making the book as readable and entertaining as we could. We hope you like it.

Thanks to the people who so generously gave their time, advice, and expertise. They are Eldon Greij, David Koeppel, Helen Longest-Slaughter, and the inimitable Tom Vargo.

J.R.

A New Phenomenon and a New Approach

• What is it that draws people to nature photography in general, and to bird photography in particular?

• What does the boom in the hobby mean to the hobbyists?

• And to the birds themselves?

Sitting perfectly still in a winter blind in the deep quiet of a Michigan snow, or lying on my stomach on a south Florida sandbar, soaked to the skin as the sun rises and the mangroves, the bay, everything takes on a wild apricot glow, I wait for the birds to come in. This is what I love about bird photography. This time, this quiet concentration in a beautiful place, I believe, is what has drawn hundreds of thousands of otherwise normal human beings to nature photography during the past two decades. This and, of course, making beautiful pictures.

With the world's renewed concern for preserving the environment, for protecting the diversity of species that share this planet, many people are taking their first good look around. They're leaving the city, their overstuffed chairs and overused cars, and walking out into the woods or the desert or the swamp. They're sailing on the oceans, or jumping into them, and rediscovering a much more basic view of the world, if only for a few days or a few hours.

During those few hours, the most amazing thing happens. When these people find themselves eyeball to eyeball with a great blue heron, or a bald eagle, or a robin for that matter, the nicks and ticks of their workaday lives fall away. It's a law of nature: You simply can't sit in the quiet watching a purple gallinule pluck from lily pad to lily pad or endure the long, tense stare of a house wren and still worry about the laundry or the soybean market. It cannot be done.

During the past thirty-some years I've taught zillions of students the art of nature photography. These students have come from many walks of life. They've been truck drivers, biology professors, lawyers, farmers, engineers, new-agers, and doctors. I've taught homemakers and golf pros, kids and senior citizens. It's a thrill to watch these people come together for a week-long workshop. Groups of individuals who would never have cause to meet on the street happily cohabit in a nature photography course with only one thing in common: Sometime before they arrived in my class they fell in love with the outdoors. They found something they wanted to photograph, some vision they wanted to capture on film.

What these diverse workshop students are experiencing, in part, is a reawakening of the hunting-gathering instinct. This instinct is central to human experience, but modern women and men are working to muffle and civilize it

1

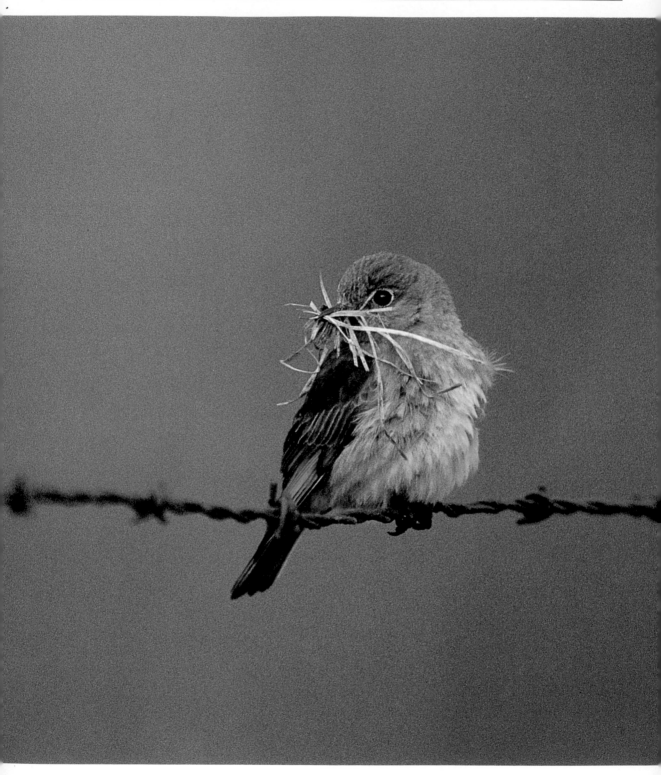

400mm lens with 1.4X multiplier, 100-speed film, 250th of a second, f/8.
The lure of bird photography has something to do with freezing a moment in the life of an Eastern bluebird as she pauses to survey her territory on the way to building her nest.

out of their lives. And yet it's there, just under the surface, unsatisfied and unfortunately disruptive at times.

Through nature photography my workshop students and I find that we satisfy this instinct without harming the environment by hunting and gathering photographs instead of animals, plants, or insects, by collecting bird photographs instead of birds.

Art through Technology

Photography is a wonderful fusion of art and science. Seeing, putting yourself in the right place, perceiving the possibilities of a photographic moment, and then applying the very sequential, very ordered photographic technology, the right mix of light, film, lens, and exposure to get precisely the image you have in mind—this is the discipline of nature photography.

Understanding, artistry, and action work together in a left brain-right brain do-si-do during the development of the photographic sensibility. In the field, hours and years of practice, layers of empirical and intuitive knowledge come together in the instant it takes for a camera shutter to open and close. If you think this

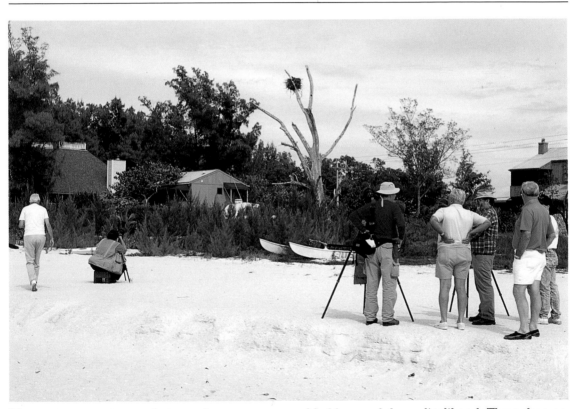

Many years ago, nature photography was an unusual hobby, much less a livelihood. These days an osprey nest constructed on a busy beach on Florida's Captiva Island brings a steady stream of camera-toting visitors, who can spend as much time trading tips as they do making pictures.

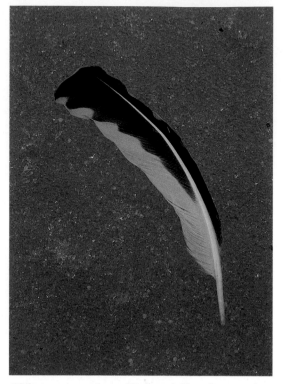

105mm macro lens, 50-speed film, 1 second, f/16.
This yellow-shafted flicker feather was probably the calling card of an eastern screech owl nesting in a wood-duck box on my back pond. My records of chance findings like this one make up a series of photographs I call "Tracks and Traces," reminders of birds and animals that have come and gone from a place before I arrived.

is beginning to sound like a Zen exercise, then you're getting the right idea.

There's no easy five-step description of how to take beautiful bird photographs. These are the products of cumulative knowledge. Left-brained, detail-oriented people have to be patient in learning to see and must develop the creative, artistic aspects of photography. Left-brained beginners often make photographs that are technically proficient but artistically dull. Right-brained, idea-oriented people must work extra hard to master the equipment. They find gorgeous compositions but can't record what they've seen because they struggle with the technology.

Learning photography is one challenge. But my personal challenge is learning as much as I can about my photographic subjects. What will you photograph? If you're interested in birds, which birds? Where will you find them? What do they eat? What eats them? When do they sleep, nest, migrate, feed? How do they sound? How do they move? How do they look when they're calm, or when they're afraid? Being the greatest artist and technician in the world won't yield much if you haven't at least basic, at best intimate knowledge of your subject. It is in the intimate details that otherwise good photos become great. Some of my own favorite bird photos contain no birds at all but document the evidence of birds, evidence I've learned to see through decades of watching and studying them.

What Is It with Birds?

What is it with birds? If you picked up this book, you probably already know but have as much difficulty explaining your love of birds to a non-bird lover as I do. Our feathered friends are just plain mesmerizing. Maybe it's because they're so very different from us. Maybe it's their bright feathers, their ability to fly, or the vast migratory distances they travel. I'm awed by birds that manage extremes in climate and by those that exhibit fascinating mating and brood-rearing behaviors.

Biologists can happily spend lifetimes study-

300mm lens with 1.4X multiplier, 64-speed film, 125th of a second, f/6.3.
Familiar and beloved by birders across the northern states and southern provinces of North America, the black-capped chickadee will always be one of my favorite subjects. I recorded this one, swaying in the breeze on staghorn sumac, on a winter morning.

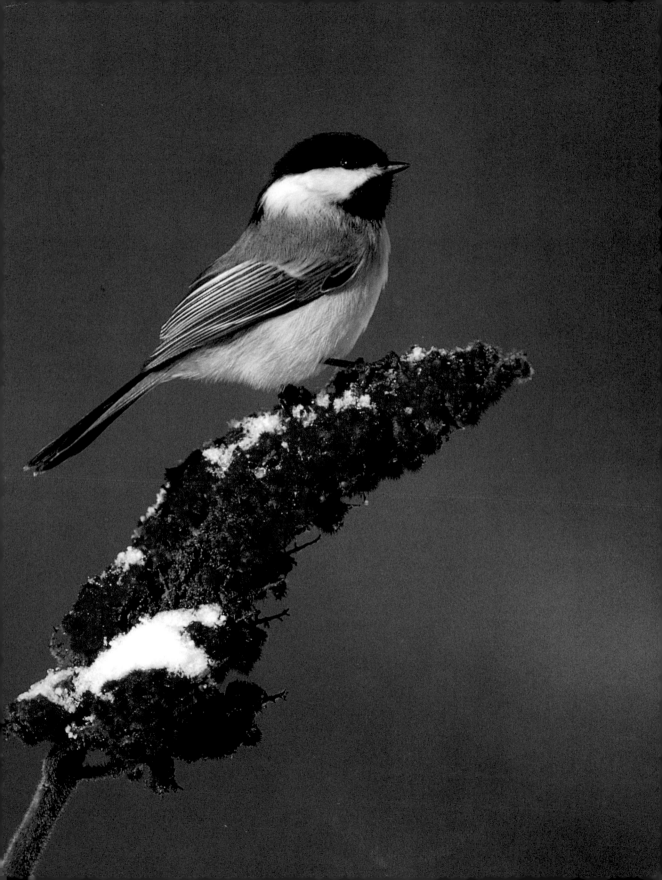

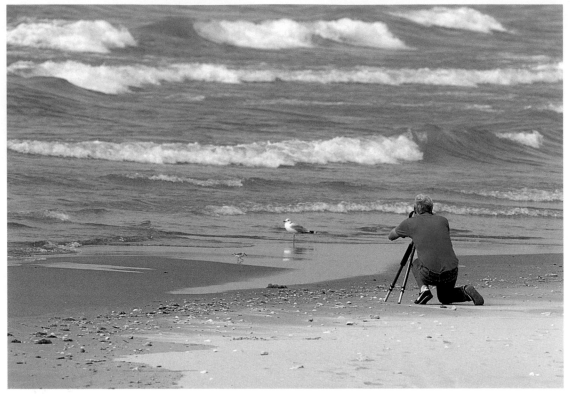

Photo by Rod Planck
Gulls are some of the most approachable birds. Before stalking this bird, or any other, I work to learn enough about its behavior to know when to back off—preferably long before my approach upsets or affects its behavior.

ing one aspect of one bird species—no wonder bird-watching has become the craze it has for so many. Special equipment, books, magazines, software, and tour groups are evidence that millions have taken up birding as an annual retreat and a daily passion. Like bird photographers, birders hunt and gather to enlarge their lists of species seen in their backyards, city parks, states, countries, and continents.

Another reason for the birding and bird photography boom is the remarkable advances in affordable optical technologies. A relatively small investment in a pair of binoculars and a field guide (and perhaps a spotting scope and a few airline tickets for the more itinerant among us) and presto, a birder is born. All our newly anointed birder needs next is a wild

place, a nature preserve, or a window to the backyard feeder.

The ease of taking up bird photography relies on advances in affordable technology too. There's a much more substantial investment in equipment at the outset, certainly, but that equipment is much better, more responsive, and usually more affordable than in years past.

Birding is a year-round hobby. Every North American season and climate brings interesting bird activity we can observe and photograph. I've taken some of my favorite bird photographs on my Michigan property during the coldest days of winter, others from my car on the way home from the grocery store. A friend of mine stops at two or three ponds and river-

beds during her morning commute to work and in hose and heels looks for ducks and wading birds. They're out there, all the time, industriously going about the business of survival.

The Light Side and the Dark Side

Things have certainly changed. In the late 1950s, when I became interested in photographing nature, I was pretty much alone in the woods. There were probably fewer than a hundred people in the United States who were serious about bird photography. Given the vast size of the country and the scarcity of serious photographers, we didn't as a group make much of a dent in the environment.

I think it's just wonderful that more people are interested in the outdoors, in spending quality time observing birds and other creatures. Certainly all the attention has helped push laws to protect endangered species and preserve more of our fewer remaining wild lands. This is the good news.

But there's a dark side to all this attention. With less wild habitat and increased interest comes vastly increased pressure on these lands and the animals that live on them. This pressure just wasn't there thirty years ago. Certain wildlife preserves in particular have become focal points or gathering places for amateur and professional photographers. Because of this, we must assume responsibility for the mark we leave. There are now so many of us interested in photographing and observing birds that we must form and agree on an ethical standard for our conduct.

The problem with still photography in particular is proximity. To photograph a bird, still photographers must approach very close. Where a birder can enjoy a duck from half a mile away through a high-powered spotting scope, we must move to within twenty to fifty feet. If we're not intelligent and careful in our approach, we can easily stress the bird away from its food or young or into the path of a predator. We can easily and unknowingly destroy the very creatures we would choose to preserve.

How we go about photographing birds, our attitudes, our actions, will determine both the quality of our own experience and the impact we have on the birds and the environment. I advocate what is being called *low-impact* photography. Photographing birds does affect their lives. This effect need not be negative. If our methods are correct and our behavior is proper, we should cause no more disturbance than would a deer or any other large, non-predacious animal.

There's an ironic payback to adopting an ethical approach to nature photography: If you make your goal a fine experience rather than a fine photograph, you'll almost certainly take better photographs. I remind my students and myself of this constantly: Natural moments don't always have to be recorded on film to be special.

The Equipment

- What equipment will you need?
- What equipment will you want?
- How do you use it?
- When do you need it?

Cameras

You've decided to take up bird photography. You know it's a challenging hobby. You know something about birds and where to find them. What's next? Well, next you'll need a camera.

A few decades of photo-technological evolution have brought would-be photographers many, many choices when shopping for this rather important piece of equipment. But as with other equipment choices, when you narrow your use to nature photography, and then to bird photography, decisions become much simpler. You should take these choices seriously. Buying into a camera system is a long-term proposition for most people. Once you invest in the camera system, especially in the optics belonging to that system, switching becomes a costly endeavor.

Understanding the technological choices available to you will help you choose the system that's right for you. I'll add my list of must-have and nice-to-have features in an ideal bird photography camera system.

How a Camera Works

Virtually all camera and lens systems employ six basic components that work together with the film and photographer to make pictures. Those components are the camera body, the

viewfinder, the lens, the shutter, the aperture, and the focus mechanism.

The *camera body* is light-tight and comes in plenty of sizes, or formats. Depending on the camera type, the body may house many components. Most importantly, it houses the film plane, which holds the film in place at exactly the correct distance from the lens to record an image. When we talk about camera formats we refer to film size, or type. For instance, a 35mm camera uses roll film that is exposed in segments 35 millimeters wide.

The *viewfinder* enables the photographer to see the area of the image being photographed. Camera types are usually discussed in terms of their viewing or focusing systems. For instance, Single Lens Reflex (SLR) refers to the mirror-and-hinge system that allows the photographer to see the image right up to the moment of exposure, through the same lens used to make the picture.

The *lens*, traditionally made of glass, is the camera's eye, allowing light to carry the outside image to the film plane.

The *shutter* mechanism is a mechanical curtain, or blade arrangement, that opens and closes to allow light (reflected from your subject) to travel through the lens and aperture to the film. The speed of the shutter's opening and closing (a 15th, 30th, 250th, 500th of a second, etc.) controls the amount of time that light is allowed to expose the film.

The *aperture*, or diaphragm, also works to control the amount of light that reaches the

Here is one camera and lens combination, set for freeze-focus photographs of a much-visited tree cavity, the cable release locked down. The equipment mindlessly waits, the shutter tripping when some subject, any subject, enters the prefocused area. I used this combination to photograph the yellow-shafted flicker that follows.

film by enlarging or reducing the opening through which light passes. In addition, the size of the aperture (f/4, f/5.6, f/11, f/22, etc.) controls the depth of field, or how much looks sharp, in the photograph.

The *focus mechanism* moves the lens closer to or farther from the film, or, with internal-focus lenses, the mechanism moves certain lens elements back and forth, to sharpen the image and to accommodate subjects at various distances.

To make a photograph, the photographer, through understanding and experience, loads the proper film type, attaches the proper lens, selects the appropriate aperture size, focuses and composes the image through the view-finder, then trips the shutter, allowing it to remain open for the correct amount of time while light carries the image through the lens and aperture to the film plane. The image is then recorded by chemical reaction on the film's light-sensitive emulsion and is ready for a processor to transform it into a permanent photographic image.

A Good Bird Camera

Over the years photographers have made many wonderful bird photographs with just about every format of camera in existence. Today, given all the choices, most professional and amateur bird photographers have settled on the 35mm SLR as their camera of choice. Why? Because bird photographers need versatility. Our subjects encompass both emus and hummingbirds. We may stalk birds with long telephoto lenses or work more closely in nesting and feeding situations. Bird photographers require precise focus and compositional control.

For these reasons we need a smaller format and a camera body that will hold enough film to allow some grace in field stalking or panning birds in flight. We need a format that will allow vast flexibility in choosing optics and film types. And *this* bird photographer needs a film format that won't cost an arm and a leg in film and processing costs.

Because the 35mm SLR is the camera of choice for so many photographers, camera companies have worked to develop technologies for this format that make field photography vastly more productive than in years past. Most new cameras make use of computer chips and electronic power supplies, "brains" that will measure your light, set your aperture and shutter speed, do your focusing, track your subject, load and advance your film, record the date, trip your shutter, and let you know when you're low on power. I still can't find one that will keep my coffee hot, but I'm sure it's coming.

All of the help from these camera companies makes photography a much more relaxing endeavor when you want it to be, but no mechanical aid will guarantee you the photos you want unless you understand how it works and when it's appropriate to use it. Certainly I cannot recommend investing in a camera that will not allow manual override of the electronic wizardry. We'll discuss when to use and when

not to use these features in the appropriate places in the chapters ahead.

Through-the-lens (TTL) Meter

A through-the-lens (TTL) meter is what its name implies, a meter that reads light through the lens to help you determine how to set your aperture size and shutter speed to deliver the best exposure for your subject. Before these sophisticated systems were developed, most photographers used hand-held meters to determine exposure, but in-camera systems have become so reliable that a separate meter is really not necessary.

Center-weighted meters, spot meters, and multisegment meters are the predominant choices in TTL meters today. Center-weighted systems place 60 to 90 percent of the meter's concentration at the center of the image area. A spot meter narrows the sensitivity area to a few millimeters in the center of the frame to allow very selective exposure readings of your subject and the surrounding area. Multisegment metering measures the light reflecting from several areas of the image, selecting an exposure that will reproduce the principal subject most pleasingly. This system balances

75–300mm zoom lens, 100-speed film, aperture priority, freeze focus.
For some situations, unattended photography yields good results. One spring I noticed a lot of activity at a tree cavity on my property. I picked a couple of good days to set up the camera rig described in the previous photo. At least eight species visited the cavity, tripping the shutter: red-bellied woodpecker, downy woodpecker, hairy woodpecker, white-breasted nuthatch, black-capped chickadee, Eastern bluebird, European starling, and this yellow-shafted flicker. The experiment cost me a few rolls of film and delivered one or two good photographs along with a record of the great spring nest hunt.

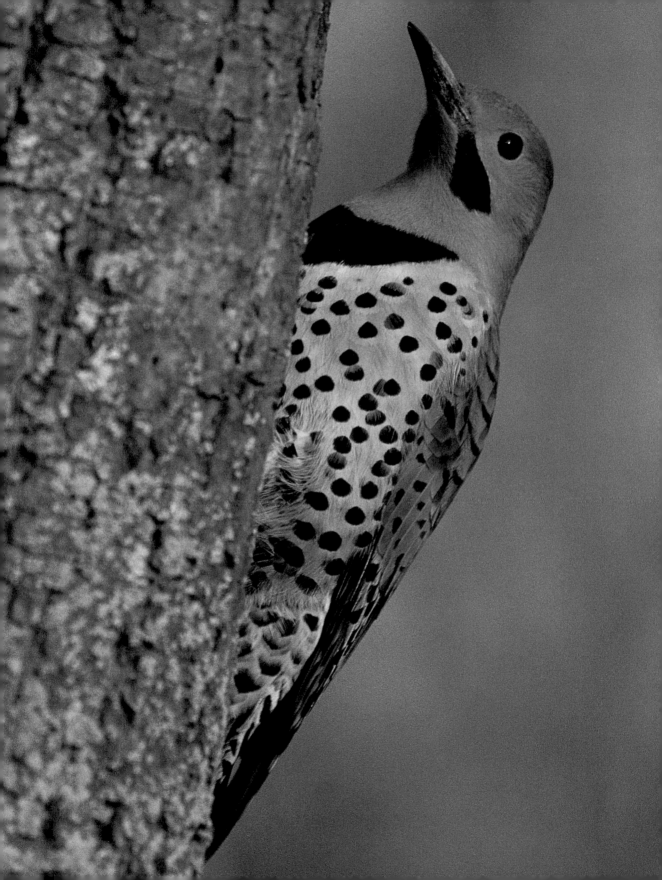

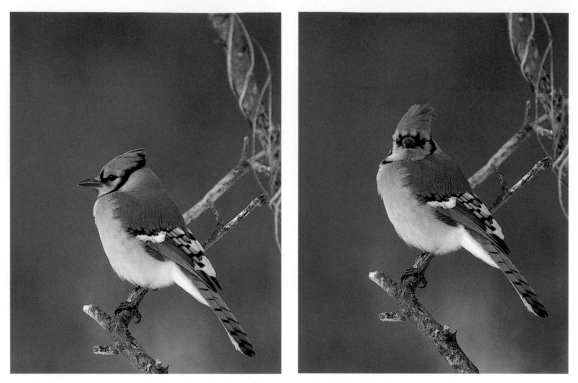

300mm lens with 1.4X multiplier, 64-speed film, 125th of a second, f/6.3.
Especially when photographing songbirds, your goal is an ever-ready camera. The precious sec-
onds it takes to back away from your viewfinder and advance your film by hand come at a great
cost when working with little birds. This windblown blue jay offered several poses during the
few moments it rested on this perch. Without a motor drive, I would have managed to expose only
one or two frames rather than five or six of this bird.

the foreground, subject, and background and suggests the best exposure. In many situations multisegment metering suggests a very good exposure, even in difficult lighting situations.

Interchangeable Focusing Screens

When viewing through your camera, you see the image as it comes through the lens and bounces from a mirror onto the focusing screen. It is then picked up by the roof prism to come through the eyepiece right side up and right way around. The screen serves as an aid to the photographer in achieving sharp focus. With current camera models, the screen chosen by the manufacturer is probably the only one you'll need for bird photography, but many different focusing patterns are available. Some provide grid lines that are helpful when composing the photograph in keeping vertical lines vertical and horizontals horizontal. Some allow more light to pass through to your eye, which is helpful when working in low light, as for most bird photography. If your focusing screen is more of a hindrance than a help, consider purchasing one of the bright matte screens that are standard on auto-focus cameras.

Motor Drive

Very few cameras today come without some sort of self-contained motor drive. These run at speeds from about 3.3 frames per second to

about 5.7 frames per second. For bird photography speed is not nearly as important as sound. Look for a quiet drive. The more noise your motor makes, the more likely you'll upset or scare off the birds you're photographing.

Exposure Compensation Dial

The exposure compensation dial allows you to fine-tune the exposure when your camera is in its automatic or programmable mode. Using this dial is the proper way to control through-the-lens flash exposures. Most cameras come equipped with this feature.

Mirror Brakes or Mirror Locks

When you trip the shutter, much activity takes place inside the camera. The lens closes to the correct aperture, the reflex mirror snaps up against the focusing screen, and the shutter bounces open and shut, causing internal movement that shakes the camera enough to ruin all the efforts of proper focus and exposure, particularly at certain shutter speeds.

On earlier cameras the solution was a mirror lock device that allowed you to lock the reflex mirror out of the light path before you tripped the shutter. When you do this, however, you can no longer see through your camera, which is awfully inconvenient when working on small, fast-moving subjects like birds.

Most of the newer cameras don't have mirror locks but employ instead a variety of braking systems and balancers that greatly reduce mirror slap and shutter bounce.

Depth-of-field Preview

For any type of photography, a depth-of-field preview is a must. This feature allows you to see what is in or out of focus at the aperture you've selected. You need this feature, because in normal mode you view your subject with the lens wide open to allow plenty of light and easy viewing. With the lens wide open, not much of your subject area will be in focus. The preview feature pulls more of your composition into focus but gives you less light for

viewing. Some people find the darker image frustrating, but if you allow your eyes time to adjust to the reduced light, you'll come to see depth-of-field preview as an indispensable feature.

Auto-focus

Auto-focus isn't the answer for every photographic situation. But virtually every 35mm camera currently produced has auto-focus capability. When auto-focus appeared in the mid-1980s there were many critics. But for a lot of reasons, particularly for those of us getting a little older and a little slower, auto-focus is a great help.

The early auto-focus mechanisms weren't much to boast about at all, but with the development of much faster systems and focus tracking, in which the camera calibrates for the speed and direction of a moving subject, photographs are becoming routine today that only luck and a whole lot of film could have produced a decade ago.

Despite all the advances, I caution all my students not to rely too heavily on auto-focus technology, especially if they have yet to learn the basics of bird photography.

Freeze or Trap Focus

Freeze or trap focus is another auto-focus feature available on some of the super-brain data backs that can be attached to top-of-the-line cameras.

This feature allows you to prefocus on a given point. When your subject passes through this point, the camera trips the shutter automatically. Trap focus is great for a perch where birds land frequently or for remote photography. If you've already invested in manual-focus lenses, there's good news. Trap focus does not require auto-focus lenses.

Fast Flash Synchronization

If you want to use an electronic flash in daylight to "fill in" a shadowy situation, you'll want flash synchronization at speeds up to a 250th

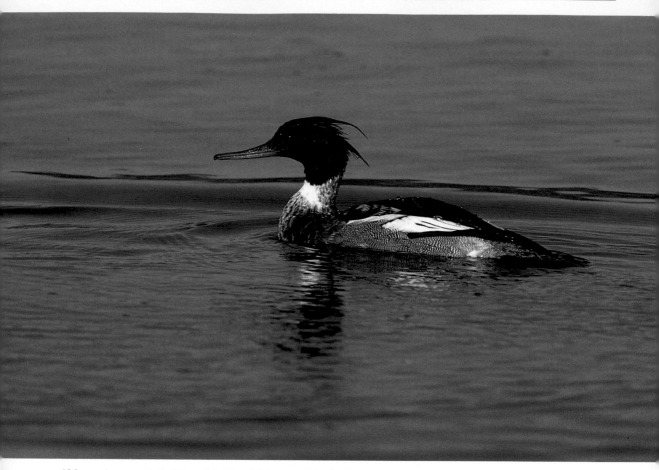

400mm lens with 1.4X multiplier, 100-speed film, 250th of a second, f/8, freeze focus. Swimming ducks don't seem to qualify as fast-moving birds, but don't be fooled. A swimming duck can move a great distance at great speed. To photograph this red-breasted merganser, I chose to use my camera's freeze focus capability. I set the focus, and when the merganser's head passed through my focus point, the shutter tripped automatically.

of a second to sharply record moving subjects and to prevent ghosting, the recording of a secondary overlapping image from ambient light.

New Camera or Old?

There are more features that nature photographers find helpful in the field—auto-bracketing, multiple exposure programs, shutter priority features—that are useful in certain situations, but I haven't found them particularly so in bird photography.

If you're looking at new cameras, virtually all

of the new 35mm SLR cameras for serious amateurs have the features listed here. But if you're interested in buying a good used camera system, I consider the first six features "must-haves"—a TTL meter, interchangeable focusing screens, a quiet motor drive, an exposure compensation dial, some kind of mirror locking system, and depth-of-field preview. The other features are awfully nice and allow you the greatest flexibility, but they're not necessary.

It goes without saying that when you settle on a camera, you should pore over all accom-

panying literature until you completely understand its capabilities. Your camera should become an extension of you, as familiar to you as a piano is to a jazz pianist, as a pen is to a poet.

Lenses

A friend of mine refers to pied-billed grebes as "teddy birds," because to him these birds look as if they should be picked up and cuddled. I'm not a grebe cuddler myself. I say let them stay wet and let me stay dry. That's why I was glad I had the optics I needed to photograph this bird swimming on the edge of a canal in Florida. The grebe was doing its grebe thing, diving and emerging, diving and emerging. To photograph a grebe you have to be ready. Ready for it to emerge, ready with the right lens.

Most successful bird photographs record moments of luck. But no amount of good luck will result in good photographs if the photographer is unprepared. Among professional and ama-

400mm lens with 1.4X multiplier, 100-speed film, 250th of a second, f/8.
If I'd been caught with my optics down, I would never have managed this pied-billed grebe portrait. Photographing this shy species takes the right lens, a little luck, and a lot of patience.

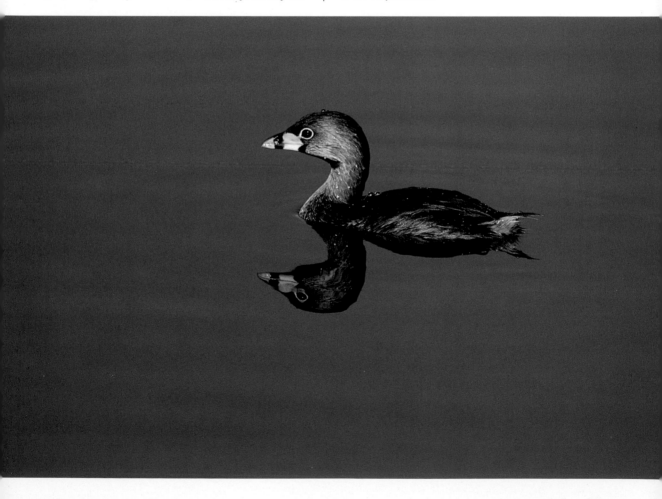

teur bird photographers, being caught with your optics down is the most common foible.

Here's a premise that applies to every piece of equipment presented in this section, but particularly to lenses: You need what you need when you need it.

I can't tell you or decide for you what you need in lenses and attachments for bird photography. I'll make suggestions, but your lens choices will depend on your budget and your use, whether your images will compete for space in national magazines, form slide shows for your local birding club, or be shared among a few friends.

So you see, it's simple: The optics you need are those that will give you results that will satisfy *you*.

Capabilities

No matter what your subject, your first concern when choosing a lens is your purpose. Which capabilities will you need for your style of photography? You'll need to consider focal length, shutter speed, and aperture size.

Focal Length. Focal length is measured in millimeters. The length stamped on the barrel of a lens—50mm, 200mm, 600mm—originally described the distance between the center of the lens and the film plane when the lens was focused at its farthest distance. Optics are configured many different ways now, but we still use this numbering system. The larger the number, the greater the magnification of the scene and the narrower the field of view.

For some reason, when heading out to photograph birds, beginners far underestimate the amount of magnification they'll need. Most birds are smaller than you think. You have to do two things to photograph songbirds: You have to get very close and you have to use a powerful lens.

For birds, a 200mm lens is the shortest I would buy. Keep in mind that for serious bird photography, 200mm is still quite short. You'd have to be less than five feet away to fill your frame with a goldfinch at 200mm. If I could have only one lens for bird photography, I would choose a 400mm. (A normal lens is 50mm, which gives the effect of eight-power binoculars, near the number most birders use.) At times a 400mm lens would be too long and at times too short, but it would be the best of all compromises. Professional bird photographers primarily use lenses in the 200mm to 800mm range.

Remember, you don't need to fill the frame with the bird to get a lovely picture. If you prefer photographs that take in the bird's habitat or you're photographing only very large birds, you can get by with a shorter lens.

Shutter Speed. The shutter speeds allowed by a lens are critical to bird photography. Shutter speed is important in capturing sharp images of fast-moving creatures. And birds certainly qualify. Even the slower birds may require speed. It's difficult to photograph a duck on a pond, for instance, at speeds much slower than a 125th of a second. Swimming ducks move constantly. The water bobs up and down, and the bird bobs up and down, moves, blinks its eyes—125th is a good, safe minimum shutter speed. For birds in flight, a 500th or 1000th are nice to have.

When photographers consider the speed of a lens, they're really discussing aperture size. Because exposure works reciprocally (more on this in Part III, Photographics), a wider aperture will always allow a higher shutter speed. For example, if you could photograph at a 30th of a second at f/8, you could also photograph at a 60th at f/5.6, 125th at f/4, etc. So if your

Don't underestimate the magnification you'll need to photograph birds; they're always smaller than we think. I chose a comfortable distance from which to photograph an immature gull, first using a 50mm portrait lens (top), then switching to a 400mm plus 1.4 multiplier (bottom).

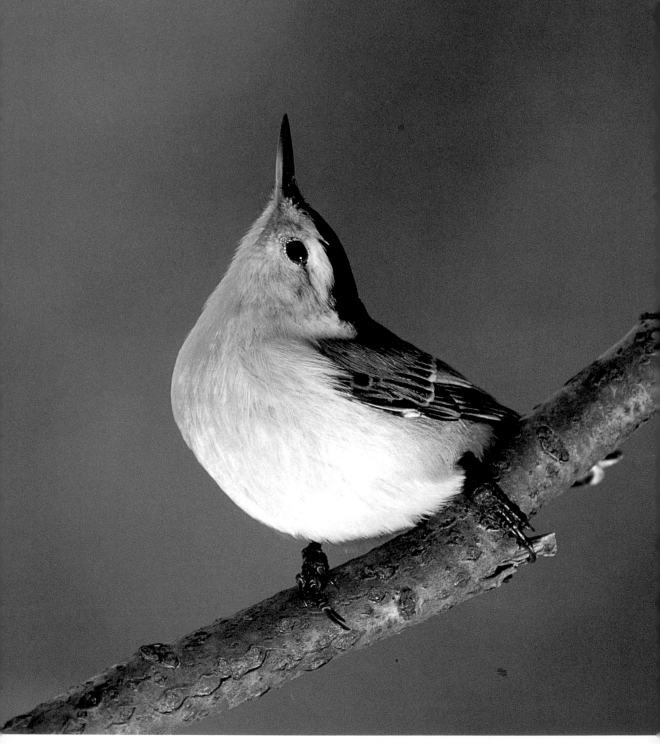

White-breasted nuthatches make a challenging subject. To photograph them you must be quick on the shutter and prepared with plenty of focal length and speed. For this photo I added a 1.4X multiplier to my 400mm, f/3.5 lens to give me 560mm of focal length. I used a respectably fast aperture of f/5.

400mm lens, 100-speed film, 125th of a second, f/3.5.
At midday, when the sun is high, black-crowned night herons head for their roosts. To photograph these handsome birds, you'll need to be up and out when they're foraging—at dawn, at dusk, and at night. For these times, when the light is low, you'll need as wide an aperture as you can manage.

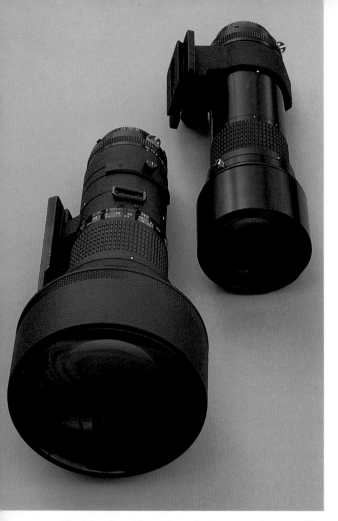

Besides focal length and aperture size, you'll want to consider size and weight of optics for fieldwork. Here you can see how aperture size makes a weighty difference in these 400mm lenses. On the left is a 400mm, f/3.5 lens, on the right a 400mm, f/5.6.

subject is moving and you assume a minimum working speed of 125th in low light, you'll want a pretty wide aperture.

Aperture Size. Many birds are more active early and late in the day when there's precious little light. To compound the problem, because of the incredible amount of detail on birds, you'll want to use sharp, fine-grain films. After choosing the focal length for your purpose, the aperture is your priciest consideration. Every

stop increase in aperture (from f/4 to f/2.8, etc.) can cost thousands of dollars.

Weighing lens speed against size, I suggest choosing lenses with apertures that fall within these ranges:

Focal Length	Aperture
200mm	f/4 to f/2.8
300mm	f/4.5 to f/2.8
400mm	f/5.6 to f/3.5
500mm to 600mm	f/5.6 to f/4

Zooms in the 150mm to 500mm range should be no slower than f/5.6.

Size and Weight

Generally speaking, the longer and faster the lens, the more it weighs. The more it weighs, the harder it is to use. If you're carrying two or three large lenses, one or two camera bodies, a tripod, a portable blind, film, notebook, binoculars, and lunch, you'll have to be in very good physical condition or not be going very far into the field. I don't ask this much of myself as a rule. For this reason I simply don't own a lens longer than 400mm.

Configurations

There are a lot of options for getting "the big image," a lot of different optical configurations for every purpose. The prime lens types most commonly used are long focus, mirror, telephoto, and zoom. Most of the new lenses in these categories, because they are made for today's cameras, assume auto-focus compatibility.

Long-focus Lenses. Long-focus lenses are very lightweight because they contain only two or three elements. They are often affordable but are long and unwieldy. With these simply constructed lenses, the barrel is as long as the focal length, so a 500mm lens is 500mm long (about 19 inches). Long-focus lenses are,

physically, the longest lenses on the market. Mirror lenses are the most compact, and telephotos and long zooms fall between. Not only are the long-focus lenses slower, but they are also awkward to handle. Consequently, there aren't many around.

Mirror Lenses. Another way to go is with folded optics—mirror lenses. These lenses reflect the image back and forth on a series of internal mirrors. This allows more compact construction but not the best optical configuration. Theoretically they're great, but the small ones don't transmit a lot of light. To get a 500mm f/4 mirror lens, you're still carrying a big, heavy piece of equipment.

Because the front mirror is located in the middle of the optical path, the light comes in around it, turning highlights, like sparkles on water, into donuts. Hot-spotting is another common problem with these lenses. This is a tendency for the center of the picture to be brightest, with light dropping off around the edges.

But overall, mirror lenses are among the most compact, lightweight, and affordable of the long lenses.

Telephoto Lenses. True telephoto lenses are my choice in prime lenses. The big, fast, state-of-the-art lenses are all telephoto. They have a lot of elements and are physically heavy but short for their focal length. These are by far the most popular of long lenses.

Zoom Lenses. Finally, there are zoom lenses that go well into the range for bird photography. You can buy 75–300mm, 150–500mm, even a 360–1200mm zoom—there's quite a selection. These lenses, in the longer focal ranges, can be relatively inexpensive or extremely costly, depending again on the aperture size. Long zooms tend to focus to a closer distance than straight telephoto lenses.

One tricolored heron at four focal lengths makes very different photos. I used the most popular telephoto lengths: 200mm, 300mm, 400mm, and 600mm.

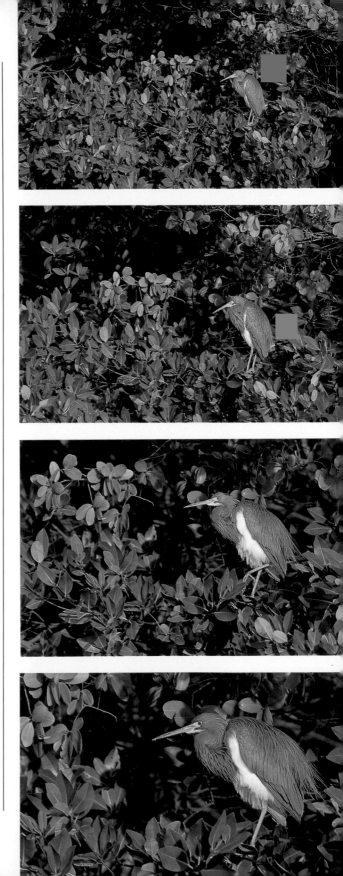

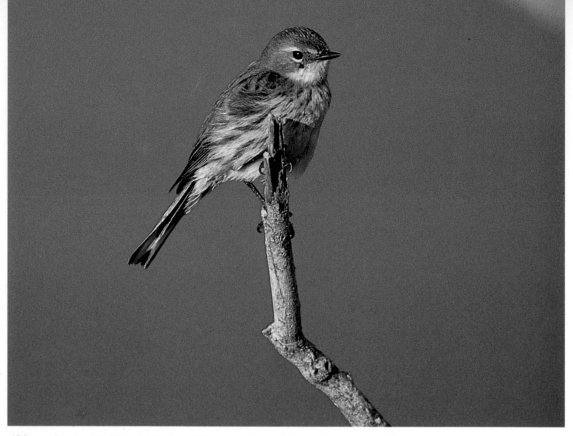

400mm lens with 2X multiplier, 100-speed film, 250th of a second, f/8.
When photographing especially small birds like this female yellow-rumped warbler, a close-
focusing telephoto lens or lens-multiplier combination is a must. The 2X multiplier I used for this
photo allowed me to double magnification without losing any of the focusing distance of my
400mm lens.

Special Features

You're trying to choose a lens. You've thought about your purpose, focal length, speed or aperture size, and lens type. So you're about halfway there. Lens selection presents several other options that will simplify your photographic life and ensure that you're ready for the lucky moments.

Internal Focus. One feature I strongly suggest in a telephoto lens is internal focus. This feature is great for bird photos because the focus is silky smooth and not affected by the weather.

In extreme cold, the barrels of an external-focus, or double-helicoid, lens will sometimes stick, making it very difficult to move. On very cold winter mornings, sitting in my unheated blind, I've actually had to grip my double-helicoid lens with both hands to turn it. In that same situation with an internal focusing lens, I could have focused with a fingertip.

Internal focusing also focuses on closer subjects. A standard 300mm helicoid lens can focus as closely as thirteen feet. The internal-focus version of the same lens can focus to about seven feet from the front of the lens. Internal focus is not commonly available on zoom lenses.

Close Focus. I always look for the closest focusing I can get. I would rather have a lens that focused down to fifteen feet than a lens that focused down to thirty feet, all else be-

ing equal. If you're considering a whole camera system, be sure to look at the focusing distances of various lenses offered by the manufacturer.

Consider the Glass. Photographic optics must focus both red and blue light rays at the same point to project an image properly onto the film. Simply stated, when light rays go through longer lenses, because of the distance of travel, they don't always come together at that common point. This problem becomes more pronounced as lenses get longer. When the light rays don't align correctly, the result is "color fringing," or "chromatic aberration," which gives photos an unfocused look. Stopping down the lens (using a smaller aperture) can help ease this effect, but in bird photog-

raphy you will often use your lens wide open to gain shutter speed. So once you get beyond the 200mm range, even the slightest difference in alignment between red and blue is going to be a problem.

Lens manufacturers have developed a solution in a special glass compound—calcium fluoride. Calcium fluoride-type glasses are great at keeping red and blue in focus. These extra-low dispersion (or ED) glasses, available from a number of manufacturers, add significantly to the quality—and price—of a lens.

Multipliers
A wonderfully flexible way of getting a long lens is to use shorter lenses with multipliers. Multipliers, tele-extenders, doublers—they go

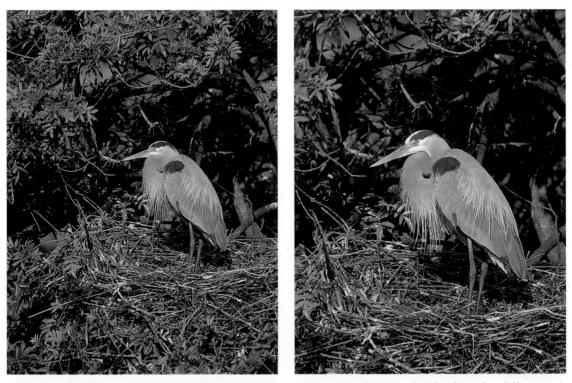

A 1.4X multiplier may not sound like a great advance in magnification, but look at the difference it made in photographing this great blue heron. I added a 1.4X multiplier to my 400mm lens and brought the viewer right into the bird's nest, showing much more detail in the plumage and bringing out the snakelike curve of the bird's neck.

by many names. Multipliers fit between your prime lens and your camera and do just what their name implies: They multiply the focal length of the lens. So if you have a 2X multiplier and you put it on a 300mm lens, you get a 600mm lens. It also multiplies the aperture; if your lens is an f/4, you end up with an f/8.

I use multipliers a lot. For example, with my 400mm f/3.5, a fast lens, I use a 1.4X multiplier to get a 560mm f/5. This is a very respectable lens, essentially a 600mm, which at f/5 is a very decent speed. The fastest prime lens you could buy in that length is an f/4, and my solution is not even a full stop slower. Not bad at all. If I add a really good 2X multiplier to the 400mm, along with some bracing, I have a very high-quality 800mm f/7.

When multiplying lens powers you have to be careful as you head higher into the multiplication tables. You decrease sharpness and contrast as you increase the power of the multiplier. A 300mm f/4 lens plus a 3X multiplier, for instance, becomes a 900mm f/11, not a very workable combination.

Unfortunately, using multipliers does degrade your image somewhat. The secret to working with them is starting out with a very good prime lens with a relatively fast aperture. A high-quality prime lens projects more lines per millimeter than most films are capable of recording. So you can degrade the image with a multiplier and not even know it. Properly used, multipliers can produce superb results.

Focusing Screens
With older cameras especially, having enough

Here is a compact, crisp lens combination for bird photography: a 300mm, f/4 lens with a 2X multiplier, all supported by a Kirk brace. The lens combination yields 600mm of focal length at an f/8 maximum aperture—very workable with films in the 100 to 200 ISO range.

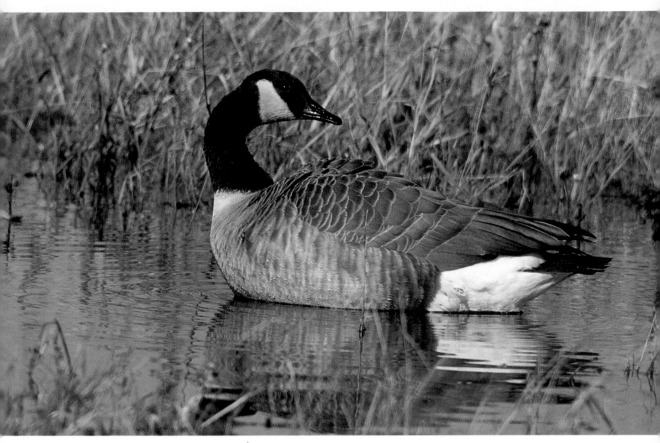

The 300mm lens with 2X multiplier combination brought me this Canada goose portrait.

light reach your eye to focus can be a problem. Birds move so fast; the brighter the image you have to focus, the better off you will be. A simple solution is to place a brighter focusing screen in your camera. You'll know you need one if the center of your split-image screen turns black when you put, for instance, a 400mm f/5.6 on it. In this case, installing a clear matte screen will solve the problem.

Extension
If your telephoto lens does not focus closely enough for your needs, you can help it along by adding a short extension tube. An extension tube is a simple metal spacer that fits between the lens and the camera body. Any lens will focus more closely with added extension. Add-

ing a 12mm tube to my 400mm lens reduces the minimum focusing distance from thirteen feet to under ten feet, allowing me much tighter compositions with sparrows and warblers.

For Beginners
Most people who get started in bird photography have already done some dabbling in general photography, have some equipment, and plan to build on it. But others start from scratch and ask me to recommend a "starter" package. Of course my starter package would begin with a 35mm SLR camera.

Next, recognizing that no lens will do everything, I would add a 300mm f/4 lens or a zoom in the 75–300mm range. This lens would be great for in-the-blind work around a nest or

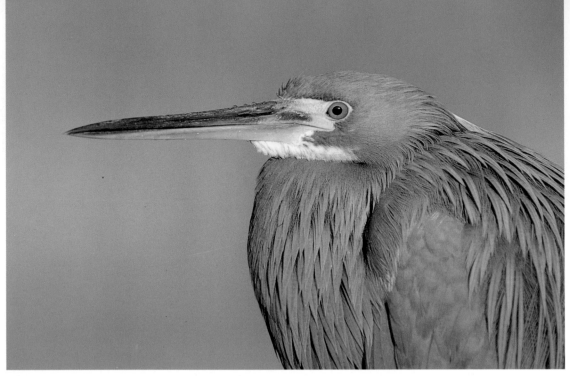

300mm lens plus 1.4X multiplier, 64-speed film, 250th of a second, f/6.3.
Large, approachable birds make good starting subjects for beginning bird photographers. Here,
a great beginner's lens combination of a 300mm lens with a 1.4X multiplier brings this tricolored
heron up close for a lovely portrait.

feeder. The next purchase should be a 1.4X multiplier to add enough length for stalking more approachable species. These lenses, coupled with the newer, faster films, are a great combination and may be the only combination you'll ever need.

The Big Lens Myth

Remember that no lens will do all the work for you. It's easy to look at one of today's huge lenses and forget that it can't work miracles. I call this the "big lens myth." When we look at a close-up photo of a loon surfacing from a pond, we see only a beautiful loon. We forget that in order to get the picture, the photographer may have had to sit or float in the pond at water level with a ten-pound telephoto lens and wait. That photographer may have been there for hours, day after day, waiting for just that moment. The right lens was essential to the composition, but so were patience and know-how.

Support

I'm a sucker for antic shorebirds. This willet and half a dozen of its cousins obliged. They formed a spectacle of fight and flight, chasing waves out to sea then turning and scurrying as the waves chased them back in.

There was beautiful light for making this silhouette. I needed a long lens, because the birds were small and jumpy, keeping me at my distance. Because they moved fast, both horizontally along the waves and vertically back and forth, a tripod was out of the question—I couldn't have repositioned quickly enough to keep up with them. So I hand-held my camera and lens, working at a very high shutter speed to compensate for my own twitchiness and the motion of the willets.

Working with long lenses and low light, you will generally need plenty of mass to support the equipment, deaden internal vibration or mirror slap, and save your arms. Generally

speaking, the more mass or weight supporting your equipment, the crisper your pictures will be. Of course, the more mass you have to carry, the slower you'll move in the field. So if you're on a day-long hike through the Chiricahuas, you'll want a medium-weight tripod, at most. Stalking snowy plovers with an 800mm lens on a wind-swept beach will take a massive tripod. If you're following gulls in flight with a smaller lens, you may opt for the lightweight mobility of a camera stock.

Hand-holding

Safe to say, most photographers know something about hand-holding a camera. Your appendages provide a terrific means of support that is popular in plenty of photographic situations, most of them having nothing to do with birds. For most of your birding adventures, you'll be working with a long lens at relatively

slow speeds, and you'll need more stability than your body can provide to assure crisp pictures.

Yet hand-holding has its place in bird photography, especially for photographing birds in flight—particularly large birds in natural light.

The secret of hand-holding lies in selecting the proper shutter speed. If you want sharp, consistent results, and I'll bet you do, make this a cardinal rule: Never try to hand-hold a lens

400mm lens, 100-speed film, 1000th of a second, f/5.6.
Hand-holding your equipment is sometimes your only choice with fast-moving creatures. Following this willet as it raced back and forth with the waves meant hand-holding and using a very high shutter speed, in this case a 1000th of a second.

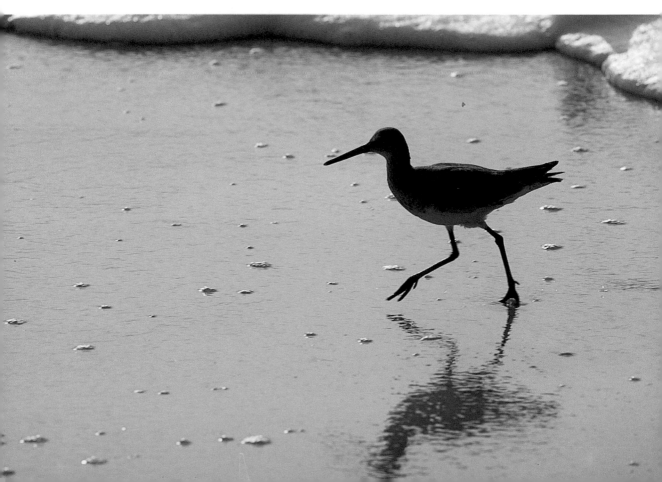

at a shutter speed slower than the lens' focal length. For example, if you're using a 400mm lens, set your shutter speed to a 500th of a second. Better yet, if you can manage a speed that doubles the focal length, you'll *always* get good results. I like security, so I try to hand-hold a 400mm lens at a 1000th of a second whenever I can.

Camera Stocks

For a little help when hand-holding your camera, you may want to experiment with stock support. Camera stocks, or gun stocks, work well for a lot of people, particularly those who find the camera body and lens an awkward handful. I rarely use camera stocks, but there

are some models I like. These are the simple, lightweight versions fitted with plates that fit the quick-release system I use on my tripod head.

Tripods

The most versatile field support for photography is a good, sturdy tripod, a tripod with mass. I looked long and hard for a tripod that was small enough to carry around and heavy enough to support my equipment. A massive tripod is so important to me in the field that I usually choose to leave extra lenses or camera bodies at home, trading in some optical versatility in favor of support, because my tripod is such a critical tool for getting sharp photos.

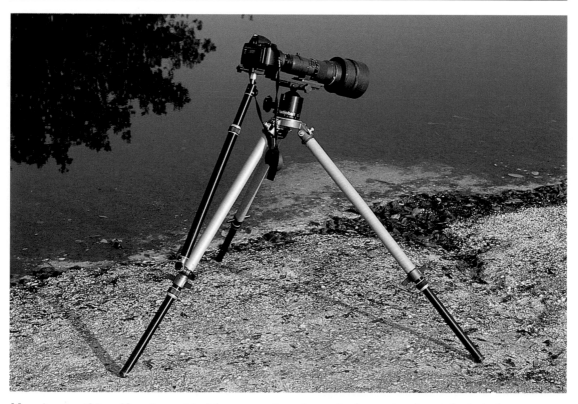

Mass is everything. Here is my ideal for support equipment when using long telephoto lenses or lens-multiplier combinations: a sturdy, 400-series Gitzo tripod with a Kirk support arm, fitted with an Arca Mono-ball head and Arca-style quick-release plates. With this support combination, super-telephoto lenses bring in sharp photos, even at slow speeds.

My tripod's legs will extend to carry my camera to my standing eye level without extending the center post. On any tripod, center-post extension will exaggerate the wobbles you're trying to avoid. Nevertheless, I occasionally use the center post to get proper perspective at low cavity nests. This is certainly a more user-friendly means of gaining height than erecting a scaffold. My tripod legs also telescope and open far enough to bring my view as flat to the ground as possible. I'm currently using a Gitzo 341, which has a removable center post, but several brands and models have these important-to-bird-photographer capabilities.

In the field, the hiking posture usually calls for balancing your tripod on one shoulder and hanging a camera bag from the other. If your tripod is as sturdy as I'm suggesting here and you have a ball-head, camera, and lens mounted to it, your shoulder will be bearing a significant weight. You'll find padding your tripod legs a big help. Padding also protects your investment when you forget to tighten down your tripod head and your camera and telephoto come crashing into the leg. Believe me, this happens to everybody.

There are some handsome leg-padding accessories available on the market. Tri-pads, for instance, are made of rip-stop nylon and padding. They go on easily, attaching with Velcro, and can be removed easily for cleaning. Before such specialty items came to light, we old-timers used plain old foam pipe insulation. It goes on tight, works very well, and is extremely inexpensive, if not very pretty.

Unipods

In the sequence of support options, unipods rate somewhere between hand-holding and a tripod. I own some unipods but almost never carry them in the field, because they don't allow me the versatility I need to be ready for the unexpected subjects or moments.

There are advantages to using unipods, of course. They're much lighter and less bulky than tripods. A sturdy unipod will double as a handy walking stick. And for fairly free maneuvering in situations that call for quick repositioning and slow exposures, unipods are very helpful.

My answer in the field, when I desperately need one-legged action, is to fold the three legs of my tripod together to give me a weighty and responsive support.

Window Braces

I work quite a bit from my car (see page 91) and tend to use my tripod there too, but lots of photographers swear by window braces, which tighten onto your car's window frame or any flat panel to support your equipment. You could attach a window brace to a window in your house to photograph backyard birds or use it within a permanent blind.

In a window brace, do invest in one of the massive designs that include support braces that fit against the door and brace on the floor of the car. I'm thinking of models I've seen from Kirk or Rue Enterprises (see Resources).

Tripod Heads

Equally as important as owning a good tripod is owning a good tripod head. A tripod head is essentially a mechanical joint you place between the camera and support, allowing you to tilt and turn your camera and lens.

The most popular tripod heads come in two configurations: pan-tilt heads and ball-socket heads. Pan-tilt heads offer great precision through individually adjustable controls that govern movement along three axes. These heads let you fine-tune and lock down each adjustment, which comes in handy when you have lots of time to set up and compose. But for bird photography, where speedy response is critical, these heads are not my first choice.

I'd sooner choose a heavy ball-socket head. The original model of these is the classic Arca Swiss Mono-ball. Today there are many Mono-ball clones on the market in various sizes and configurations.

The classic model comprises a large Teflon

ball and a very rugged frame. Because of its mass, it will support basically any lens. The ball-in-socket construction allows you to freely maneuver your camera and lens, then lock it into place.

Look for a head that offers a separate, smooth pan control, so that you can follow the action of walking or flying birds without unlocking the main controls. Look also for easy, comfortably located locking levers and knobs. You'll want a head you can adjust easily without taking your eye from the viewfinder.

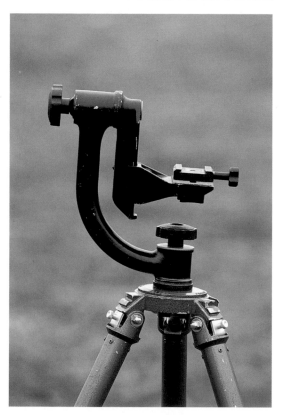

Another tripod head choice, particularly useful for following moving subjects, is the Wimberley head. This unusual-looking piece of equipment uses a gimbaled design to rotate the lens around its center of gravity, keeping lens and camera balanced even when the controls aren't locked down.

Quick-release Plates
When you suddenly need a different lens, or another camera system altogether, you'll bless the soul who invented quick-release systems. My favorite quick-release is a heavy Arca-style plate that supports my big lenses. The Arca system's long, dovetail plates slide back and forth, so if you put a differently weighted camera on the back of your lens, you can slide the plate to rebalance the system.

My second favorite quick-release system is the Bogen hexagonal-plate system. The Bogen system is very sturdy but fixed within the mount, so it is not quite as responsive as the Arca design.

Support Braces
Most telephoto lenses are carefully balanced to sit comfortably on a tripod or tripod head with a camera body hanging off the back. So as soon as you begin adding long multipliers between the lens and the camera body, the balance is thrown off, and the chance of shutter bounce and mirror slap affecting your photos greatly increases.

If you've opted for the Arca quick-release system, you can take advantage of one very workable solution to this problem—a long plate fitted with an encircling collar for the multiplier and a quick-release for the lens. The two optics become one solid unit, vastly increasing your support and allowing much slower shutter speeds.

Photographing at Middle and Slow Speeds
When you use big lenses at the awkward speeds—from a 15th to 125th—I would not recommend locking your ball-head controls completely or using a cable release. Instead, keep the controls slightly loose so you can follow action, and keep one hand on top of your lens, the other over the shutter button. This way any vibration from the camera will be absorbed by your body. A low profile offers less wind resistance, so keep your tripod as low as you can.

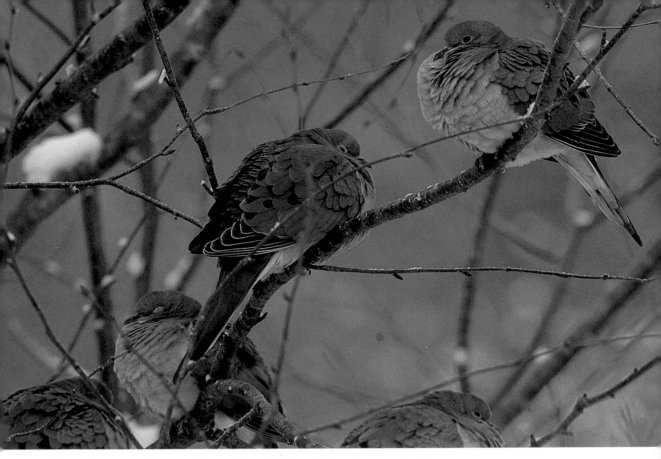

400mm lens with 2X multiplier, 100-speed film, 30th of a second, f/7.
The winter light was gray and low as I photographed these roosting mourning doves. I used a 400mm lens with a 2X multiplier fixed with a Kirk brace to shoot at the slow-for-birds speed of a 30th of a second.

This is especially true with medium-weight tripods, whose lowest leg sections are often quite flimsy.

Test, Test, Test

All cameras react differently. You should always test new equipment with the old so you are never surprised. To test my support system, I attach my camera body and longest lens. On a bright, sunlit day I take a number of photographs of a front-lit subject, something with hard edges, like cereal box print. I start by using the fastest shutter speed I can, let's say a 500th of a second, and work reciprocally in slower speeds until I reach a 15th of a second. If everything works as I'd hope, the photos taken at the slow speeds should be just as sharp as those taken under the same conditions at the faster speeds.

If you're going to use different kinds of support, run the test with each support system. Find out what your equipment can do on a window mount, on a tripod, hand-held, or with your tripod head mounted into a permanent blind.

If your photographs are not sharp at slower speeds with any of the support systems, it's fairly safe to assume that your camera is simply incapable of handling the slowest speeds with your longest lenses. If razor sharpness is important to you, you may need a different camera body for bird photography.

Film

Choosing what you'll put in your camera can be much more mystifying than choosing the camera itself. At the rate new films and updated emulsions enter the market, even professional photographers, whose film loyalties run deep and strong, find themselves confused.

Confusion is built into the system. Film companies work at a sort of alchemy, melding aesthetic concerns with emerging technology in their search for the perfect emulsions—those that will consistently deliver the "ideal" image. Unfortunately, the technologies are not consistent, and no one agrees as to what makes an image "ideal." Fortunately, our subject narrows the field of possibilities. For bird photography, the field of suitable films is narrow enough that making choices is much more interesting than exhausting.

The best bird photographs would be made with an emulsion that delivers images of razor sharpness at extremely high speeds. This film would display all the color and contrast of the most flamboyant tropical plumage and all the rich and subtle distinctions of tone and color in a lush jungle setting. This film doesn't exist. But there are films that come delightfully close.

E-6 and K-14

Most bird photographers choose slide film for its sharpness, versatility, color reproduction, and cost. When we talk slide film, we're really talking about two types: coupler-in-emulsion, or substantive, films, also known as E-6 films; and coupler-in-developer, or nonsubstantive, films, the K-14 films.

With the coupler-in-emulsion E-6 films, color coupler molecules embedded in the emulsion form dyes that create color in the transparency. These films are the Ektachromes, Fujichromes, Agfachromes, and Scotch Color Slide films. For coupler-in-developer films, color is produced during the K-14 developing process. These are Kodak's Kodachromes.

Professional and amateur nature photographers tend to use transparency films. If you are a print film fan, there are marvelous emulsions available or being developed in the 100 to 400 ISO range that are perfect for low-light bird photography. Talk with your film representative to find out which print films would be right for you.

At this writing it's impossible to point to any one film that is the hands-down best for bird photography. But you can easily narrow your choices. For photographing birds, you will want as sharp an image as possible, one that will pick up the extremely fine details of bird feathers. You will want color that you like, and as much speed as you can get without losing detail or color.

Sharpness and Speed

Sharpness and speed have historically been rivals where film choice is concerned. In general, the faster the film, the more grainy the image. With big lenses, slow, sharp films give very little flexibility in shutter speed and depth of field.

Film speed is expressed by an ISO (International Standards Organization) number. (We old-timers remember these as ASA numbers, but ISO is today the measurement organization recognized by film manufacturers around the world.) ISO numbers describe the film's sensitivity to light. The lower the number, the "slower" the film. Slow films, those of ISO 25 to 64, require longer exposure to light and for fast-moving birds are a bit too limiting for my taste, restricting lens selection and the time of day I can make photographs.

The fast slide films, with ISOs of 400 or more, are great for low light, but distinguishing marks and luminous colors get lost in their grain. Color print films tend to behave more predictably in faster emulsions.

My tastes run to the medium-speed slide films. I have found speeds of 100 to 200 to be very workable for most situations, and the cur-

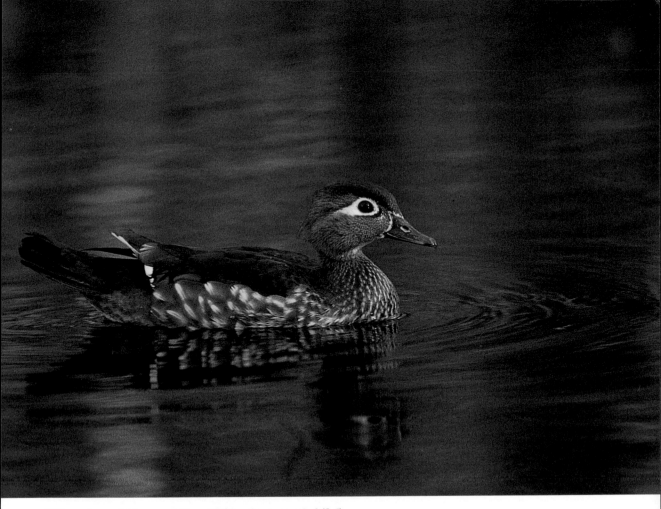

400mm lens, 200-speed film, 125th of a second, f/3.5.
A boon to bird photographers are the new, fast, sharp film emulsions being released, updated, and rereleased at a faster rate each year. I photographed this female wood duck on Kodachrome 200 using a 400mm, f/3.5 lens. The light under the wooded canopy was very low, but the speed of this film allowed me to stop her swimming action at a 125th of a second.

rent and ever-improving sharpness of films in these speeds is astonishing.

Color

Studying color qualities of films can be both fascinating and confusing, but it's important to understand what sort of color performance you can expect from various films. People believe they want films that yield "true color." But Isaac Newton taught us that there is really no such thing as true color. Color is an experience of waves of light and exists only in the mind of the beholder. Remembered color is nearly always more vivid than experienced color. We remember hues as more saturated, dark colors as darker, light colors as lighter.

Film color needs to satisfy our memories' perceptions. Some films give very vivid, saturated colors. Others are more muted. Many have a cast, or bias, toward one color or another. Some are more magenta, some warmer yellow, others cool, or blue. What it comes

down to is taste: The only way to know your preferences is to test the film.

A Film to Suit Your Habits

While you're keeping thoughts of speed, sharpness, and color preference in the air, don't forget to remember your photographic style. You'll want to use films that are readily available to you. Or if you have to travel to get it, does it store well? A film's age affects image quality. You can guard against using film that is either too young or too old by opting for professional films. Most film types offer the choice between amateur and professional emulsion batches. Professional films are usually the same emulsions as the amateurs but are aged in batches by their manufacturers, who match them to rigid speed and color specifications. These batches of film are monitored for professionals who demand the highest consistency in image quality.

Stay Tuned

I like the idea of standardizing on one or two films to keep life from being more confusing than it ever needs to be. But if you take this advice, do keep your ear to the ground. There are plenty of photography periodicals on the market that render sound professional opinions on the performance of new and updated emulsions (see Resources).

The science of film manufacturing is changing faster now than ever before. I am almost positive that the film I'm using today won't be the film I'll be using six months from now. Remaining open to changes will allow increasingly creative approaches to your subject matter. And when the alchemists of the film industry have arrived at the perfect emulsion, you'll be ready.

Remotes

One of the ways you can reduce your intrusiveness when photographing birds, particularly when photographing them at the nest, when they're most vulnerable, is by removing yourself from the scene and letting the equipment do the work.

You can do this by purchasing one of several remote-control triggering devices on the market today. These devices are really only practical if your camera is fitted with a motorized film advance. The devices range from the lowliest air release to very complicated, and much more costly, infrared and radio gadgets.

The air releases are, of course, the simplest of the offering. Your limitations with cable releases are largely in their manual operation and the length of the cable itself. But releases are indispensable for remote triggering under many conditions.

Infrared remote-control units come in two parts: a transmitter, which produces an infrared beam, and a receiver, which you mount with your camera. To use infrared technology effectively, you have to position the receiver to allow a clear path for the beam from transmitter to receiver. Most of these units allow several modes for triggering the shutter, from immediate to automatic.

More sophisticated than the infrared units are the radio-controlled units. Radio devices have the vast advantage of being operable in a range of several hundred feet rather than the under-one-hundred-foot range of the infrared systems. They can be used to trip your shutter from afar.

A Larry West Portfolio

Photography isn't a team sport. It's a perfect pastime for the introverted and the reflective because it's something of a solitary practice.

As he works to make this photograph, a dozen thoughts flash between West's ears. He calculates exposure, considers the film and the movement of the bird. He sets the camera for freeze focus, composes his photograph, and follows the bird while tripping the shutter two, maybe three times.

What does he want? A detailed gull or silhouette of the gull? How dark should the sky be? His shoulders and neck begin to ache from having held twelve pounds of equipment to his face for the past hour, for the past thirty years. He compares this bird to laughing gulls he photographed twenty years ago. For these moments, the other photographers he's traveling with have disappeared.

West spends the better part of his life alone, quietly stalking shorebirds, quietly sitting in his blind, his brain abuzz with questions, imaginary discourse, new workshop lectures. Maybe it's a solidarity among the solitary that draws West to make photos like this one—a lone silhouette of a gull, quietly floating on rigid wings, always working, always looking for food, intent on its purpose, fighting the setting sun.

Laughing Gull in Flight
400mm lens, 100-speed film, 1000th of a
second, f/5.6.

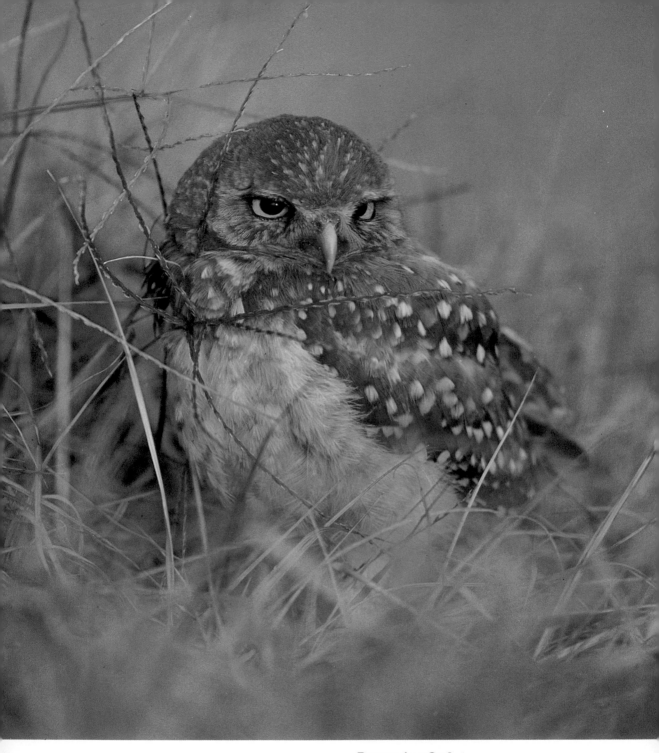

Burrowing Owl
400mm lens with 1.4X multiplier, 50-speed
film, 30th of a second, f/5.6.

When West arrived on this scene, the birds were bored. Several members of Florida's isolated and diminishing population of burrowing owls chose a field next to a Fort Myers library to raise their young. Their western kin, too, often pick bustling homestead sites on airport strips, golf courses, and the like. They look for burrows already started by tunneling mammals and move on in.

Though short on burrowing owls, the sunshine state may boast more native and visiting nature photographers per square inch than any other in the Union. West guessed that most of them photographed these owls during the hours before he arrived. Busloads of photographers. Tours of photographers. The nesting ground had become a nature photographer's free-for-all, with sometimes fifty to sixty cameras clicking and whirring at a time. The birds couldn't have cared less. They fell asleep on their spindly legs, swaying in the breeze.

West arrived late in the day. Just two other photographers stayed to wait out the late afternoon light that promised a grand twilight. As the light dimmed, the owls perked up and began their low cooing, their chattering. Though burrowing owls are diurnal, they're most active late in the day and early in the morning. By sunset, the sky filled with owls, like enormous moths flitting about in the moonlight, low-flying, landing sometimes as close as three feet away from the photographers, who were well rewarded for their patience.

Time and again West has proven there's no place like home. He's spent decades devoted to his backyard species. As it happens, West's backyard comprises some twenty-eight acres of central Michigan's second-growth woods, fields, and swampland.

Thousands of mornings of mist, ice, and fog have come and gone, and West has worked them, encased in one of his homemade blinds or a camouflage bag. He has waited patiently for the same birds to land in the same trees and branches, yielding amazingly diverse photographs. Each is a moment plucked from space and time. The same birds, flowers, butterflies, and reptiles offer up an inexhaustible supply of photographic opportunities.

The wild canary yellow of the American goldfinch startles even the most experienced birders each spring. But many are surprised to learn how late the goldfinches stay through winter. The brilliant plumage takes its leave long before the bird does. The deep cold of the night before must have startled this little winter-plumaged finch, which woke hungry and cold to a frosted world. The bird was heading for one of West's feeders through a soft morning light and paused for the moments it took to record this portrait.

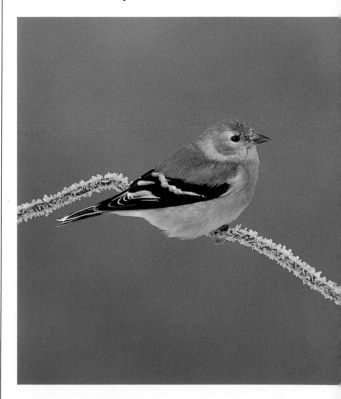

American Goldfinch
400mm lens, 100-speed film, 125th of a second, f/8.

The decisive moment. Being ready for the unexpected. During workshop seasons—spring, summer, and fall—West coaxes, cajoles, drives home this point above all others: You need what you need when you need it. If you're not there and ready, you won't get the photograph.

Bluebirds were on the day's agenda. West set up his blind to photograph a bluebird box,

using plenty of focal length to give the birds room. But while in his blind he heard the trilling song of this chipping sparrow coming from very nearby.

It didn't take long to find the bird, on a singing perch near the bluebirds' nest box. It was making its rounds, staking out its territory, and warning off other chipping sparrows. Every half hour or so it came back around, landed in front of the blind, sang for three or four minutes, then moved on to its next gig. The lapses gave West plenty of time to compose and trip the shutter while keeping an eye on his bluebird agenda.

Chipping Sparrow
400mm lens with 1.4X multiplier, 100-speed film, 250th of a second, f/8.

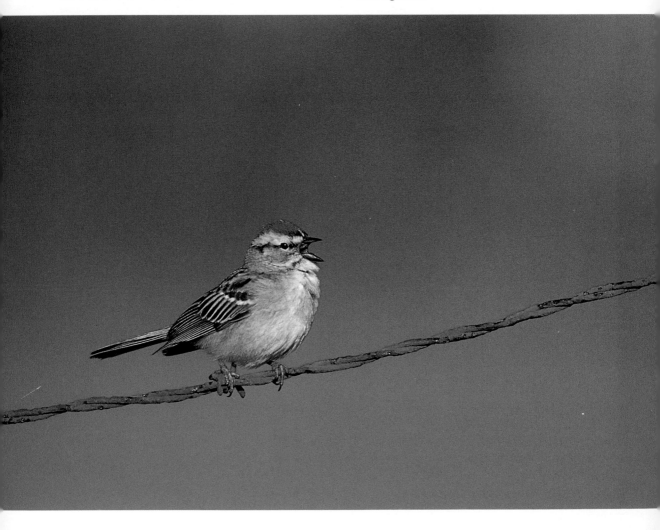

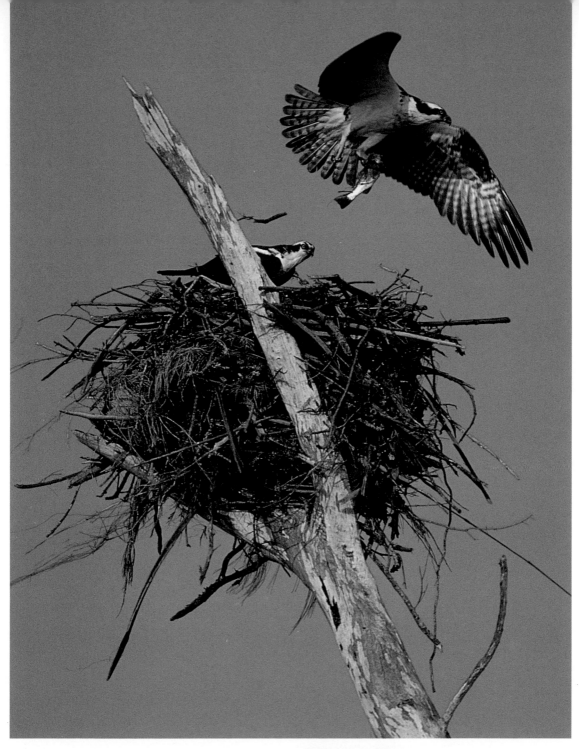

Ospreys at Nest
400mm lens, 100-speed film, 1000th of a
second, f/8.

There's something very satisfying about stalking a bird, especially when so many experts say it can't be done. But the successful stalk of this osprey nest (page 41) lost some of its pride-engendering power when West had to pick his way among several other photographers, making sure not to position his equipment in the way of folks and parked cars and the traffic of the two-lane highway behind them.

Wildness is relative for birds on the comeback trail. Here West had the opportunity to photograph handsome representatives of a species whose population crashed during his lifetime because of chemical, territorial, and predatory intrusions. A gorgeous nest. A beautiful sky. A handsome pair. What an opportunity. So what if it wasn't an original thought. West knew his photograph would be different from his neighbors'. The birds were completely oblivious to the watchers, to the drone of traffic, and to the whirring and clicking of the cameras.

Mallard
400mm lens, 200-speed film, 125th of a second, f/3.5.

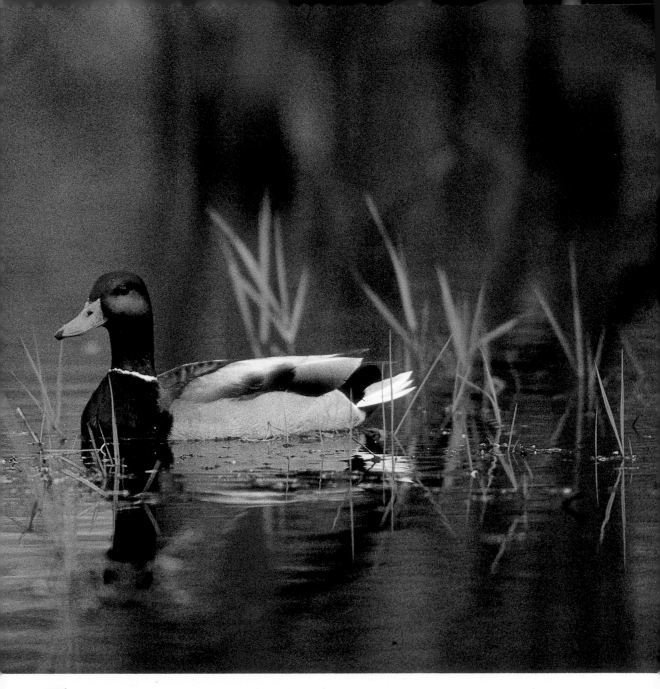

Every year West hauls his blind back to his backyard flooded area, where he knows ducks will land each spring. The blind will be in place before the ice breaks and the first webbed foot hits water. When that day comes, West will climb in, testing ever sharper, faster films and new equipment.

The low morning light under West's wooded canopy gave an excellent opportunity to try out the 200-speed film with his fast lens. The mallard's crisp markings and bustling behavior made it a perfect candidate for the film. The equipment and film allowed West a fast enough shutter speed to stop action and enough light to grab all the detail this bird offers.

43

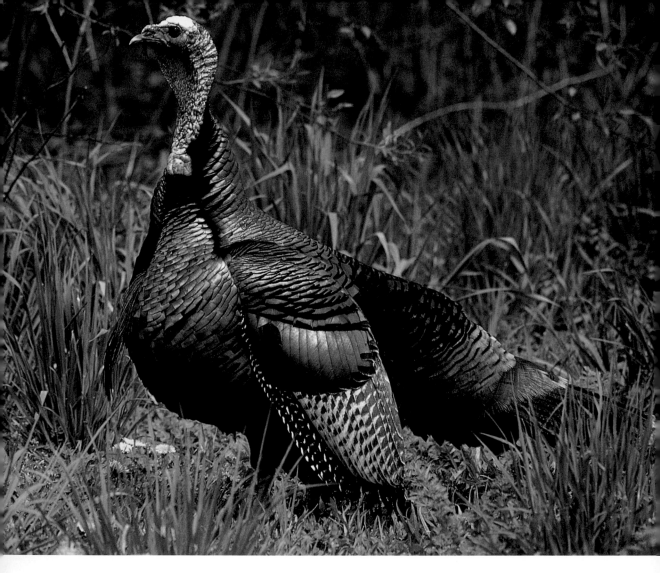

Wild Turkey
300mm lens, 64-speed film, 125th of a
second, f/8.

B ird sanctuaries make great photography
arenas. The birds are protected from hu-
man predation and are therefore much more
trustful of the two-legged creatures slyly mak-
ing their approach.

The only difference between sanctuaries of
old and sanctuaries today, says West, is that
many more unenlightened photographers are
making their presence felt in a number of un-
pleasant ways, forcing the keepers of these
places into taking actions and regulating traffic
of all who tote cameras. The rules keep wildlife
harassment to a minimum but restrict the con-
scientious along with the careless.

This gobbler wasn't going to be spooked off
by any middle-aged blond man approaching
him sideways through the meadow. No sir. No
ma'am. *This* gobbler was busy showing his
stuff, letting the warm light of the late after-
noon sun dance across his russet and amber
plumes, sending hearts aflutter among any
number of females lurking in the nearby
underbrush.

Pine Grosbeak
400mm lens with 1.4X multiplier, 100-speed
film, 250th of a second, f/8.

A pine grosbeak foraged for seeds or insects from this cornhusk lily near Telluride, Colorado (page 45).

West was playing the itinerant photographer, traveling west when he saw this opportunity. An unpredictable moment, not the sort of thing you can set a blind for when you're on a short visit, even if you'd planned ahead and packed a blind. West would have to stalk this busy songbird.

Even as he began walking his crooked path to the bird, West knew his chances of getting a good frame were very low. He started off on his agonizingly slow approach with long lens and tripod, staying focused, his head clear of all but bird. He watched it at least as carefully as it watched him. A mere two hours later he was done, having made a few frames and achieved this one good one.

Worth the effort? For West, yes. It was a new bird, at the southernmost tip of its range, and a new experience.

Wood Stork
300mm lens, 64-speed film, 30th of a second, f/4.5.

The sun rises over the Everglades, rays reaching out across the tops of the cypress trees to cast a warm glow over the white-and-black plumage of this regal sentinel. A wood stork, looking for all the world as if it would single-birdedly defend its species' dwindling numbers against all oncomers.

These endangered colonial birds, found predominantly in Florida, are very sensitive to rising and falling water levels, which disturb their ability to feed themselves and their young.

West stared at this bird. The ancient, grizzled face stared back. He knew he wanted to remember this. He wanted a record of this bird, on this morning, in this beautiful light. West pointed his camera up toward a stormy sky, planting his tripod in the cypress swamp to gain as much sharpness as he could for the slow exposure he needed to preserve the effect of the light. He waited patiently for the sun to rise, crossed his fingers, and tripped the shutter.

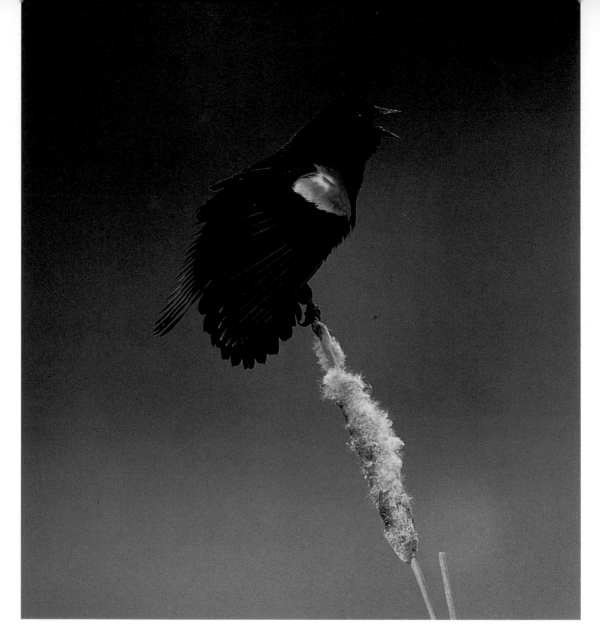

Red-winged Blackbird
400mm lens with 1.4X multiplier, 100-speed film, 250th of a second, f/5.6–f/8.

They really do seem to appreciate the attention, the blackbirds singing their hearts out in turn as the car drives along, stopping every few feet, while the human inside clicks and whirs in appreciation.

This is one of West's favorite springtime scenes: the vibrant, dramatic colors of the male red-winged blackbirds cleaving to the khaki vertical stripes of dead cattail stalks. These birds are so industrious, working tirelessly to attract mates, singing without end. They don't seem to mind or notice the car's starting and stopping engine. They live by the side of the road, and this is just another one of those nonthreatening metal things that whiz by hundreds of times a day. No sense in getting worked up over it.

A human fisher or photographer could learn a lot about patience by watching herons at work. A heron moves so slowly, without wasting a calorie, standing still for what seems eons. Just when you think it has snoozed off in boredom—or you have—its neck is transformed to a bullwhip, snapping a

stiletto beak into knee-deep water to come up with one of the many morsels that will sustain its elegant body for the day.

This tricolored heron on Eco Pond in Everglades National Park was no different; it even caught West a little off-guard as the bird tossed this tadpole in the air to better position it for ingestion. As if waiting for the slow photographer to catch up with the program, the bird posed a second time with its catch, long enough for West to record five or six frames before it finished the meal and went back to work.

Tricolored Heron
300mm lens with 1.4X multiplier, 64-speed film, 250th of a second, f/8.

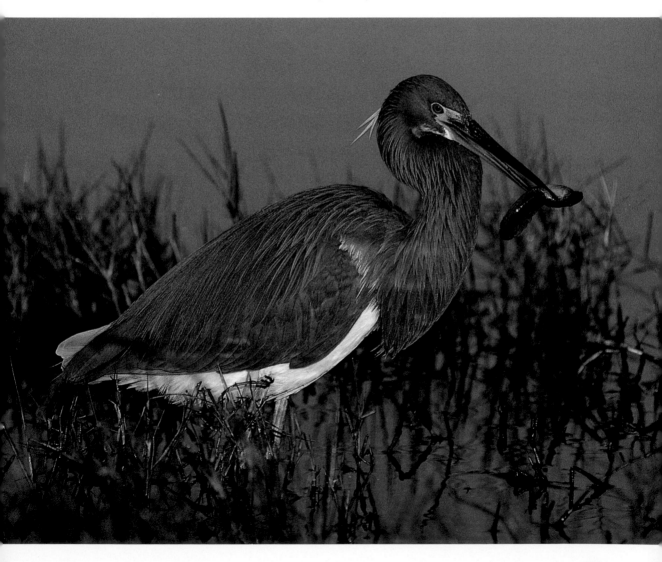

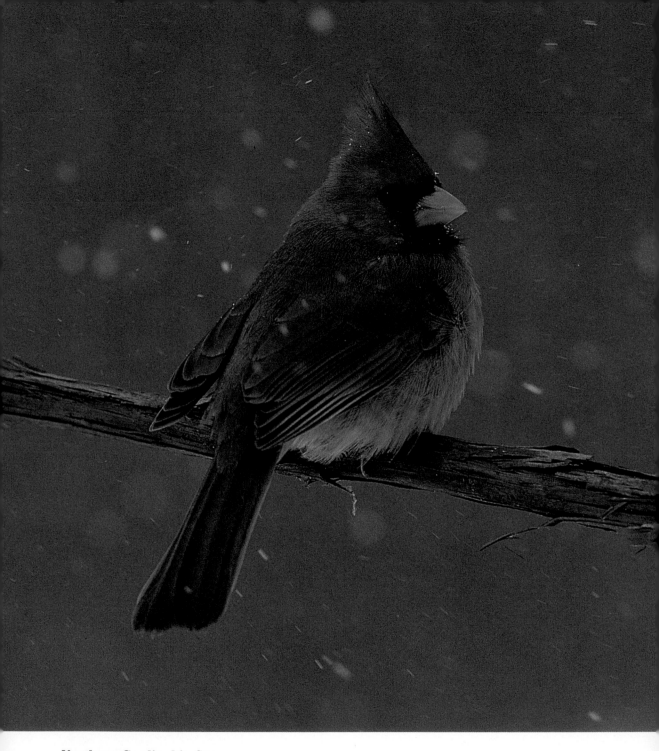

Northern Cardinal in Snow
400mm lens with 1.4X multiplier, 100-speed
film, 125th of a second, f/5.

Maybe it's easier to capture the essence of a bird in the cold when you share its condition. West did in this case. He'd sat for any number of winter mornings in his unheated blind, watching the snow come down, feeling his fingers go numb. He'd seen cold cardinals around. He wanted a cold cardinal photograph.

When you're hungry as well as cold, when your ungloved fingertips have gone from chilled to pained to numbed and still you haven't gotten the photo you've been after, you come closer to understanding the nature of cold. Your body is asking for coffee, warmth, anything but this. Your mind is making you stay.

Then the bird comes in. A beautiful cardinal sits down before you, fluffs its feathers to maximum heat-saving capacity, and hunkers to wait out the snow. You could kiss this bird with your chapped lips. And that snow! West chose to share the beautiful misery, picking a slow enough shutter speed to record the angle and drive of the flakes as they hit bird and blind.

When is a bird photo not a bird photo? For years West has been fascinated with the idea of recording tracks and traces—hints at the wildlife that was there just before he arrived. Clues to the things that go on, very much without us, every minute of the day.

This photograph was a matter of light and careful composition. It shows an eye for design and moment. A decision to record not moving tracks, but stationary ones. Tracks of a bird just sitting still for a minute, then flying off when the time came.

It's a hint at something. An editorial state-

Herring Gull Tracks
200mm macro lens, 50-speed film, 4th of a second, f/16.

ment, really, though West is shy editorially. He wouldn't come out and point a finger if he had to, but he'll give us an opportunity for introspection. There's more to the world than meets our eyes. He answers that nagging old question: If a tree falls in the woods when no one's there to hear it, does it make a sound? Of course it does. And unseen birds leave prints.

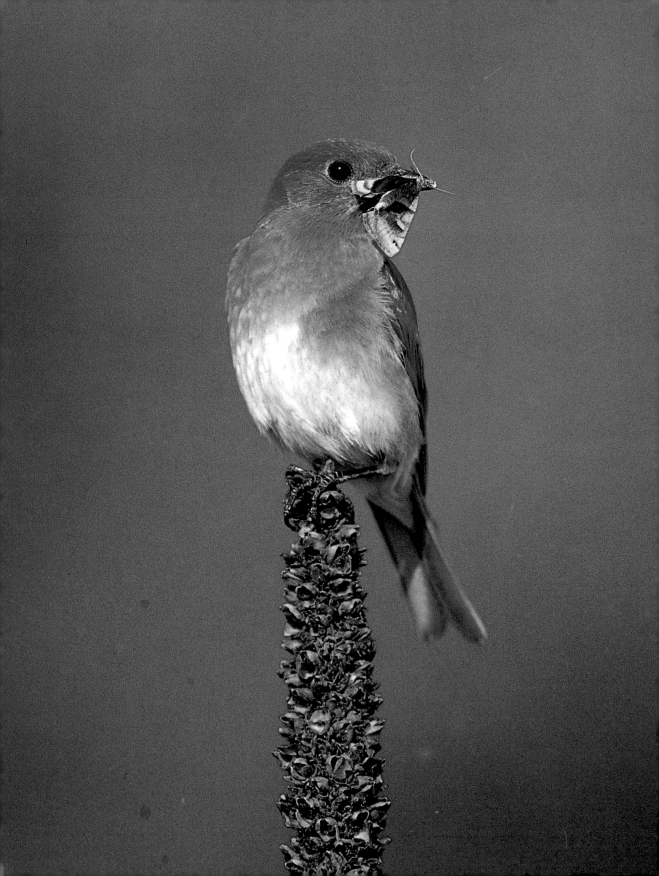

Eastern Bluebird with Moth
400mm lens with 1.4X multiplier, 100-speed
film, 250th of a second, f/8.

Spending every day outdoors means always thinking in seasons. West never goes about shaking his head, wondering how summer turned into fall so quickly. He impatiently anticipates the next season or the next year, when already planned photographs can be realized.

This Eastern bluebird portrait had been planned more than a year before the shutter clicked. West first received permission to erect bluebird houses along a fencerow of a nearby open field—habitat favored by bluebirds. His blind was in place two or three months before nesting began, positioned for ample view of the territory, including the tall mullein stalks West knew would sprout at the correct spot.

All that was left was for spring to spring. Then West climbed into his blind and waited for beautiful bluebird moments. They came.

There are times when a familiar bird stumps you because of some difference. This female cardinal at first left West wondering if he'd seen a whole different species. West called her the harlequin, and getting her picture became something of an obsession. She must have been low on the pecking order among the cardinals that visited his back woods. This photograph was the result of one of her very few visits, visits cut off by other birds chasing her away.

West hosted the bird for one winter, then never saw her again. She was special. He remembered a line from the Loren Eiseley poem "Magic": *How does a man say to his fellows he has been enchanted by a bird?*

Piebald Northern Cardinal
400mm lens with 1.4X multiplier, 100-speed
film, 125th of a second, f/8.

Great Egrets
300mm lens, 64-speed film, 60th of a second, f/4.5.

A gold rush, and only a few witnesses. What more could a panner want?

West got this photograph on Mrazek Pond in the Everglades one late afternoon. While it was still sunny, there were close to a hundred photographers and viewers there, the parking lot jammed with cars, folks milling about to look at and photograph the few birds on the pond. West joked that he couldn't quite load his film without elbowing someone.

But as the sun dropped down people trickled away, then left in hordes, until barely any light and only three photographers remained. Then it happened. The sun hit just the right angle for alchemy. The water turned to gold.

Great egrets up to their backward knees in liquid gold. Low contrast. The three opened up their apertures, slowed down their shutters, and scooped up their treasure.

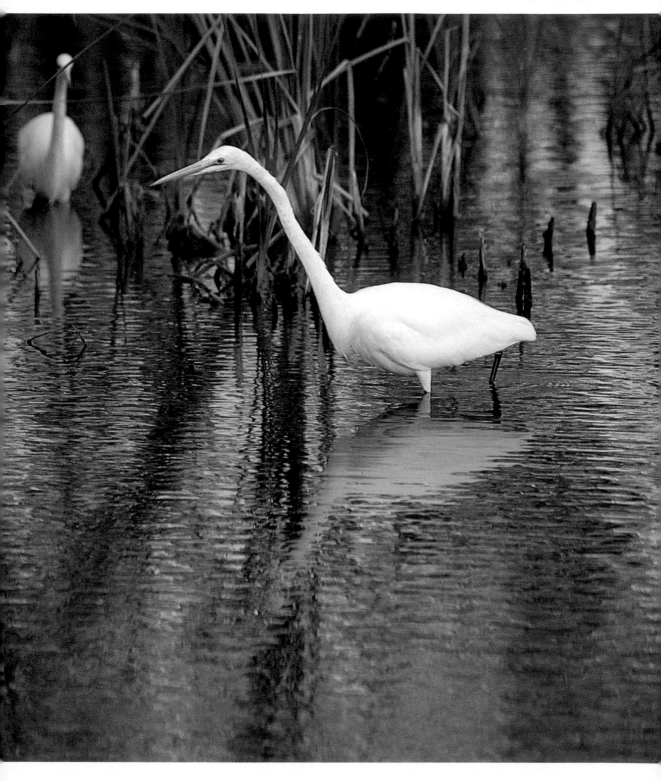

There is a proven success ratio in bird photography: The more time you spend in the field, the more fine bird photographs you will have. But the truth in this axiom is not that you'll get a few good frames with each outing—many days West returns home without ever having tripped his shutter.

Many times there's nothing to see. Or there's plenty to see but no opportunity for a good photograph. Or the light's wrong. Or the lens won't focus closely enough. Or he's suddenly out of film.

Female Red-winged Blackbird
400mm lens with 2X multiplier, 100-speed film, 30th of a second, f/7.

And then there are those other days. The rare days. The lucky days. The light is good and the birds come in and pose forever, almost tripping over one another to land in front of his lens. On this day, West climbed into his new bag blind at the edge of a neighbor's pond. He was photographing wood ducks when this beautiful female blackbird flew in. The light, the perch, the bird—everything was right about that moment, just as everything had been right for the wood duck photo taken moments before, just as, moments later, everything would be right for sandhill crane portraits.

The more time you spend in the field, the greater your odds are for experiencing these rare days.

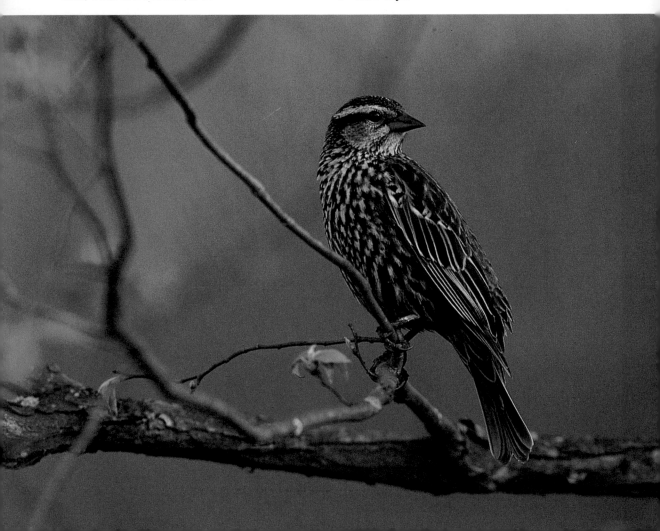

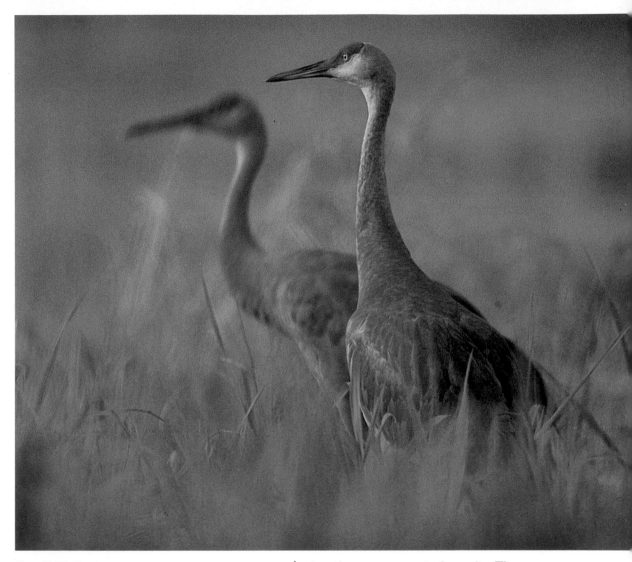

Sandhill Cranes
400mm lens with 2X multiplier, 100-speed film, 30th of a second, f/7.

After one long sit, producing wood duck and blackbird portraits, and just when West was ready to pack it in for the day, he glanced up and nearly jumped out of his blind as twelve feet of wing, carrying two sandhill cranes, came flying straight for him.

The pair landed so close he wondered about his safety for more than a minute before find-ing the camera controls again. They were so close, in fact, West couldn't quite frame an en-tire bird. The lenses were too powerful. And so he stayed for quite a while longer, quietly and contentedly making a series of close-up crane photos.

Cranes are startling even when they aren't flying straight for you. Once they were fairly common, but the steady drainage of North America's wetlands has resulted in steadily de-clining numbers for these statuesque natives, which require wet and undisturbed nesting habitat for survival.

Photographics

- You have your equipment, now what?
- How do you make a photograph?
- How do you calculate exposure?
- What about using flash?

Exposure

Perhaps no single challenge is as frustrating to beginning photographers as understanding and using the camera's exposure controls. But the anxiety dissolves naturally once you fully understand these four photographic truths: 1) The camera can't think. It's a *tool* you use to record the picture you want on film. 2) In any given photographic moment, there is *one amount of light*. Just one. It's your decision how you'll use it. 3) Your meter doesn't see color, it *registers tones*. 4) Modern cameras are factory-calibrated to record what your meter reads as a *medium tone*. Learn to see the tones, and think in tones, and good exposures will follow.

Reciprocity

Photographers describe exposure settings—various aperture sizes and shutter speeds—as "stops." To "stop up" or "open up" means to widen the aperture or slow down the shutter speed to allow more light to reach the film. "Stopping down" or "closing down" refers to narrowing the aperture or increasing the shutter speed to allow less light to the film.

Each stop measurement, either in aperture size or shutter speed, is always double the previous, or half of the next, stop value. So in shutter-speed sequences, a 60th of a second is two times faster than a 30th (one stop faster) and a 15th is two times slower than a 30th (one stop slower).

Aperture stops work the same way, but because we're dealing with the size of the opening that lets light to the film, the numbers look a little strange: f/2.8 lets in twice as much light as f/4 (one stop faster), while f/5.6 lets in half as much light (one stop slower).

We balance aperture and shutter-speed stops to create different kinds of photographic effects while recording a given subject. This balancing act, or *reciprocity*, is easier to grasp with a camera in your hands than it is just reading about it from a book. If reciprocity is new to you, now's a good time to pick up your camera to use as a reference for the rest of this section.

In any scene, at any given moment, there is one amount of light bouncing off your subject. It is either natural light or light you've supplied with a flash (see page 69, Light and Flash). You will use your camera's meter to measure that light and discover the *base exposure* for your photograph. This base exposure determines the amount of light available to your camera. If you open up your aperture one stop *and* close the shutter speed down one stop, your camera receives exactly the same amount of light as it did for the base exposure. Closing down the aperture by one stop and opening up the shutter speed a stop again gives your camera the same amount of light to do its work.

Follow along with your camera in hand, changing the settings as we suggest here: Set

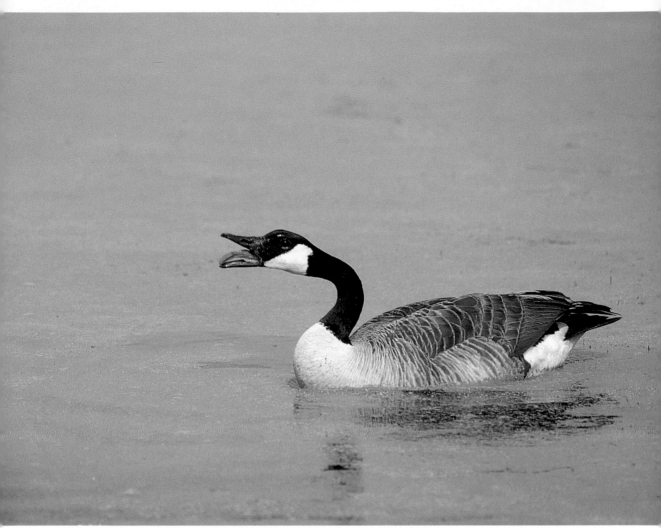

300mm lens, 64-speed film, 250th of a second, f/8.
Oh Canada! A honking Canada goose in duckweed. The black-and-white plumage of this hand-some goose calls for precise exposure setting. This photo illustrates the extremes of the tonal range in color slide photography, from the whitish of the bird's cheek patch to the dark of its darkest plumage. The diffused, low-contrast light made it easy to capture the entire tonal range. And the duckweed provided a good medium tone for metering.

your shutter speed at a 60th of a second and your aperture at f/5.6. Now move your aperture to f/4 and your shutter speed to 125th. Then close down your aperture two stops to f/11 and open up your shutter speed two stops to a 15th of a second. At all three settings you are letting in the same amount of light.

Sacrificing Speed for Depth

Why is reciprocity important? In considering shutter speed, remember that faster shutter speeds stop action. For very fast action, like a bird in flight, you'll want to use a very fast shutter speed or the bird will be recorded as an interesting but shapeless blur across your pic-

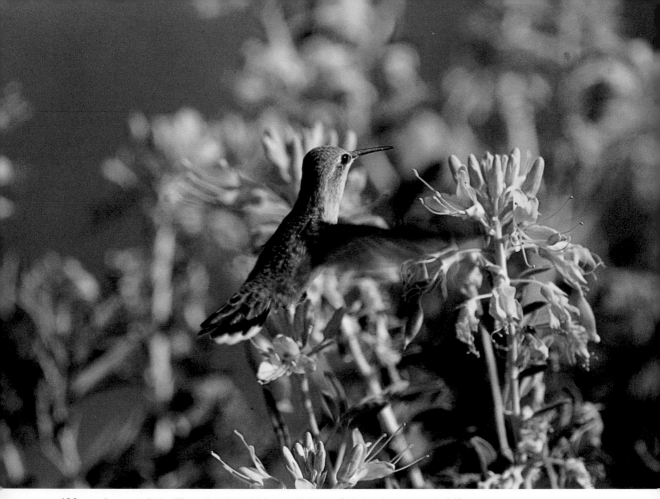

400mm lens with 1.4X multiplier, 100-speed film, 500th of a second, f/8.
To stop the action of this immature hummingbird I needed a very fast shutter speed. The light and my film would allow a 500th of a second, which was enough to stop the movement of its body, but I would have needed a much faster speed to stop the motion of its wings.

ture. If you want to use a faster shutter speed and your camera needs more light to register the photograph, you can get it by opening up the aperture as you speed up the shutter.

Narrower aperture sizes record more distance, or depth of focus, in your photograph. This range of in-focus image area is called "depth of field." The larger the aperture, the more shallow your depth of field. As you page through birding literature, you can see that bird photographers often sacrifice depth of field to stop fast action. That is, they choose larger apertures and faster shutter speeds. For birds in flight, a 1000th or a 500th are good

speeds. For foraging birds, a 500th or a 250th are safe. For sunning, incubating, or other fairly stable postures, you can go as low as a 125th, or even a 30th or lower with some of the newer, low-vibration camera bodies. But use a slower speed and you begin to take some risk of losing sharpness to camera shake, especially if you're using a long telephoto lens.

What Is Proper Exposure?
Let's redefine a couple of common terms. *Underexposure* happens when the exposure settings you chose produced a picture that is darker than you wanted it. *Overexposure* hap-

pens when the settings you selected produced a picture lighter than you wanted it.

Proper exposure is achieved when you've set the camera's controls to record just what you want. Most bird photographers want a *literal translation* of the subject—want it to look pretty much as it does to their eyes, no darker, no lighter.

Seeing Tones

The film you put in your camera is a primary dictator of exposure. As we've already pointed out, color slide film, for its sharpness and versatility, is the norm in bird photography. Unfor-

tunately, color slide film is also the most unforgiving exposure-wise. One stop too much or too little, and you just haven't got a workable image.

Every picture has within it a range of distinct tones of lightness and darkness over which it can record the details of a scene. Photographers distinguish several levels of tonality (Ansel Adams described these levels as "zones") ranging from detail-less light to detail-less dark.

If this tonality stuff is beginning to sound confusing, let me make it more clear: Tones can be translated directly into exposure stops.

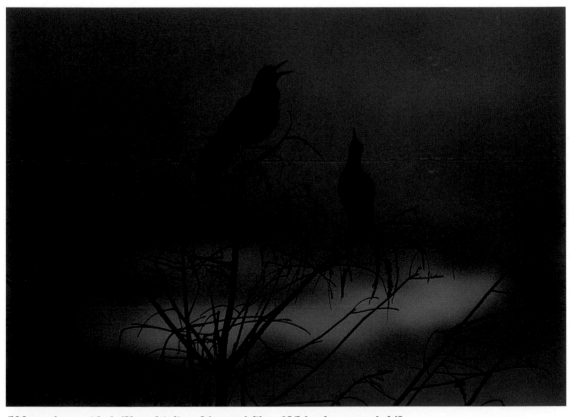

500mm lens with 1.4X multiplier, 64-speed film, 125th of a second, f/8.
In any situation, there is one amount of light—in this instance a small amount. But something about these boat-tailed grackles against the dawn sky caught my attention. I metered the sky and set my exposure to place the darker clouds in the sky at medium, knowing the grackles would lose all detail, becoming silhouettes of grackles in my photograph.

61

It is common knowledge that slide films can record literal tonality over a range of only about five stops per film frame. That kind of thinking is confusing for many. Just remember this: You cannot record detailed black and detailed white in the same photograph. In high-contrast scenes you'll have to compromise.

There are five tonalities I find easily recognizable and most useful in helping me determine exposure. They are as follows:

105mm macro lens, 50-speed film, half a second, f/22.

Narrower aperture sizes record more distance, or depth of focus, in a photograph. To record these savannah sparrow tracks I needed a healthy depth of field to keep tracks and sand razor sharp from front to back. For this photo I used a small aperture and slow shutter speed, first setting my equipment on a very sturdy tripod.

Whitish—Detail-less white. Two and a half stops lighter than medium. Snow without detail. The tone of the back side of a photographic gray card.

Very Light—The tone of fresh snow with detail, a great egret, or tundra swans. Very light is two stops lighter than medium.

Light—The same tonal value as the skin of your palm, most yellow flowers, or the pale brown of dead cattail leaves. Light is one stop lighter than medium.

Medium—The tone of most grass and the northern blue sky at sunny midday; the tone of a photographic gray card.

Dark—This tone can be found in many tropical broadleaf plants, old red oak bark, bison, and black birds with sheen. Dark is two-thirds to one stop darker than medium.

Because our eyes register color and automatically adjust for the range of tones they encounter with each glance, learning to see in tones takes a little practice. We tend to talk about tones as whiteness and blackness, which is misleading. Your camera reads the tonal range of all colors equally. For example, you can have medium red, light red, dark red, or very light red; light blue, dark green, etc. Any color can be any tonality.

Using Tonality

Your camera's light meter, you'll be happy to know, isn't nearly as smart as you are. Metering systems on today's cameras range from not smart at all to very smart. All of them are very good at measuring light; none of them can take the place of your photographic knowledge. When even the most intricate metering system takes a light reading of a great egret feeding in a mangrove, it tries to find the happy medium. It doesn't know, unless you tell it, that you want an egret to look like an egret. It sees only a vast tonal range from dark to

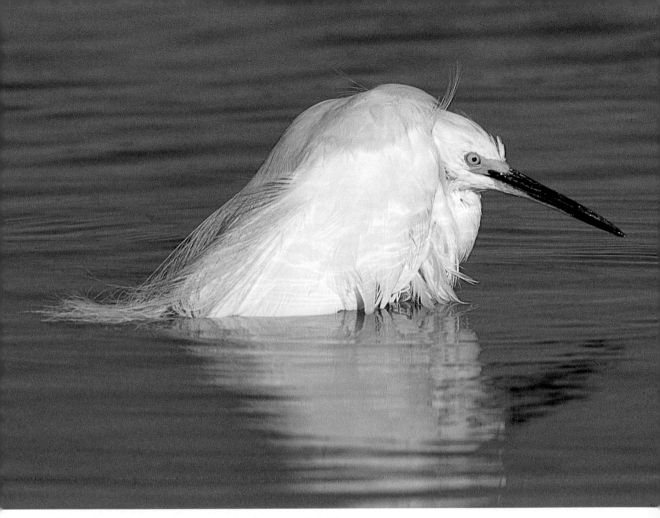

400mm lens, 100-speed film, 250th of a second, f/16.
Learning to recognize tones is not all that complicated. This snowy egret is happy to show off its
very light, detailed plumage, two stops lighter than the medium blue water. The water's reflection
of the egret is light, and the bird's shiny black bill is dark, two-thirds to one stop darker than
the medium water. The brightest, detail-less portions of the bird's plumage, at the very center of its
wings, are whitish.

whitish and seeks a compromise. But is it compromising on behalf of the mangrove or on behalf of the bird? Understanding how your meter works is essential, but relying on your own ability to see and to think, then using your meter as a tool, is really the only way to ensure proper exposure. Remember, your meter will try to record the scene it's pointed at in a medium tonality. If medium is not a literal translation of your subject, you'll have to do something to make it the proper tone.

Here's how these exposure elements come together. You'll find your subject in the viewfinder, get a base exposure reading, then ask yourself the key exposure question: What tonality do I want to make this subject?

If you're out in the summer and spot a male cardinal feeding in a wild raspberry bush, you'll set your speed at a 500th to stop the motion of his very active feeding habits, then take a meter reading of the bird and its background. Both the bird and the background

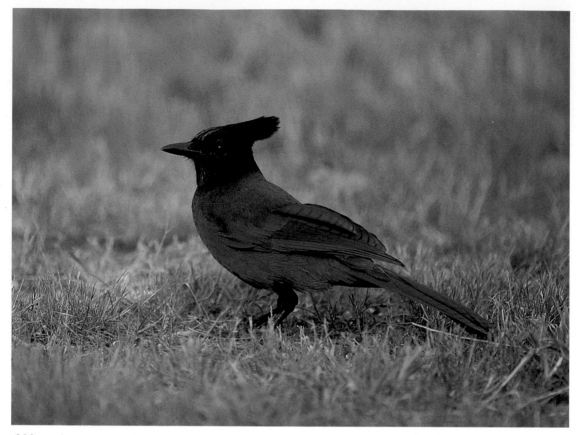

300mm lens with 1.4X multiplier, 100-speed film, 125th of a second, f/8.
A medium-blue Steller's jay on medium-green grass—the easiest exposure to calculate. Simply meter the composition and use the exposure your camera's light meter suggests to record the bird and grass as medium.

have medium tonal values, and you want them recorded literally in your photograph. This is the perfect condition for your medium-seeking meter. So you'll simply set your aperture dial to the suggested stop setting and trip the shutter.

Finding a medium-toned raspberry bush in the same lighting as your subject made that exposure easy. But medium tones aren't always available. In December that cardinal may feed on a snow-covered bush against a background of white snow. If you could get close enough, and ask that cardinal to hold still, you might be able to take a reading of the medium red bird itself, and your camera would suggest a proper exposure. But you can't, so when you take your reading, your camera sees a lot of light snow and suggests an aperture that will make that snow medium (gray), which would in turn record the bird in a blackish tone. If you use this suggested exposure, you'll have a very under-exposed photograph.

Here's where your knowledge of tonality takes over. *You* know that snow is whitish—two and a half stops brighter than medium. You know your camera will try to make the snow medium. So to get a proper exposure for the bird, you simply take a reading of the snow and "open up" two and a half stops to compensate (because it's a two-and-a-half-stop distance to move your snow from medium to whitish).

64

So if the camera meter suggests a setting for the snow of a 250th at f/11, you compensate by enlarging the aperture two and a half stops to f/5.6–f/4. Now the cardinal will be medium red.

Let's try it again. The cardinal flies away, as cardinals will, and lands on a large patch of dark ground. Your camera wants to make all that darkness a happy medium. You know the

400mm lens with 1.4X multiplier, 100-speed film, 125th of a second, f/8.
A tree sparrow presents a somewhat more complicated exposure problem. While the bird may be medium overall, it won't hold still for a light meter reading. In this case I metered off the medium, out-of-focus background and set the camera to record a literal translation.

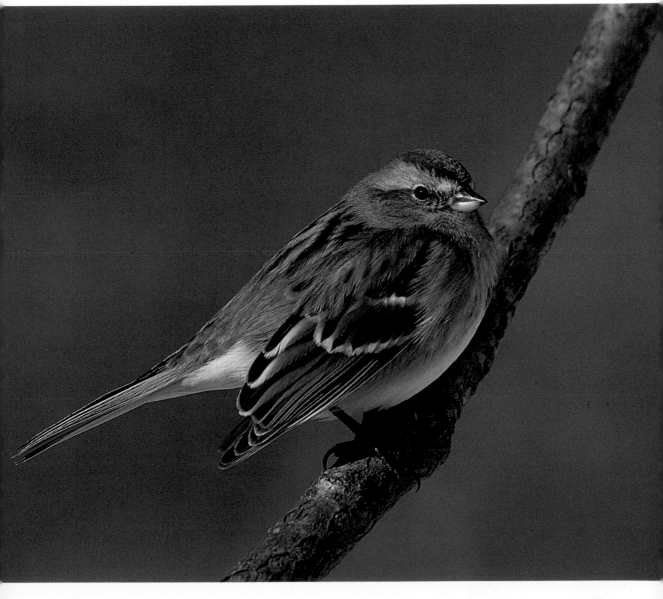

400mm lens with 1.4X multiplier, 100-speed film.
If I let my light meter do all the work, I'd end up with photos like the one on the left. The meter
wants to record what it sees as medium. But this composition is almost entirely whitish. To
photograph very light birds like this great egret, meter off the body and open up two stops for a
detailed white.

ground's tone is dark, one stop darker than medium. So you take a reading of the ground and *close down* one stop. And again, the cardinal will be medium red.

Tonal Tricks

Once you've become used to tonality, you can begin to appreciate the subtle effects you can achieve at the ends of the tonal scale.

When you "expose for the light tones" in slide photography, it means stopping down for *just enough* detail in the highlights—not too much or you'll end up with muddy images. For instance, if I were photographing a great egret against dark mangroves, I could meter the

dark background and close down one stop to get a literal translation of the mangroves. But my subject is the egret, which is whitish. So instead of using the exposure I just calculated, as I would with a light or medium subject, I'll

300mm lens with 1.4X multiplier, 64-speed film, 60th of a second, f/6.3.
Dark subjects, like this smooth-billed ani, are two-thirds to one stop darker than medium. In this case, to bring out the sheen and iridescence in the soft light, I metered off the medium foliage and opened up two-thirds of a stop for maximum plumage detail.

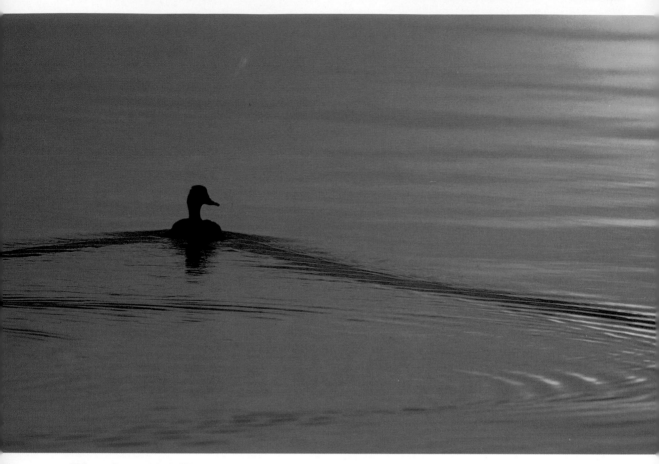

400mm lens with 1.4X multiplier, 100-speed film, 250th of a second, f/5.6.
How do you like your sunsets? In this case I wanted a slightly-deeper-than-literal translation of the scene. I metered the water, which was slightly lighter than medium, and used the suggested aperture setting to capture the water at this rich medium orange-and-gold and place my mallard in silhouette.

close down one half stop more to give me better detail in the bird's plumage. If I could fill the meter area with the egret (a spot meter is nice for this), I could place the bird as very light by opening up two stops. Both techniques will give me the same exposure.

I have to remember that when I do this, I also change the tone for the rest of the scene. In my Florida photo, the mangrove may drop down to very dark, particularly in bright sun. And that would make a pretty uninteresting picture. I like to photograph both very light

and dark subjects earlier or later in the day, or when the sky is overcast, making the lighting more diffused and the tonal range easier to handle.

But let's say you're interested in getting the beautiful pinks of sunrise or the flashy oranges and purples of sunset. Now you have another kind of choice. Do you want exactly the sunrise you see before you? Or would you like those pinks more saturated, more dense, than they actually appear? If so, close down a half stop. Or do you want the fog foggier? Open up

a half stop. In this case you may move a little away from a literal translation in order to give more feeling to the scene. It's your choice.

Working in Automatic

If you prefer to use your camera on automatic, this tone system still works. Most importantly, it's helpful to understand these photographic principles in order to understand what your camera is, or is not, automatically doing for you. If your subject is one stop darker than medium, dial in a minus stop on your camera's compensation dial. If it's two stops lighter than medium, dial in two plus stops.

Remember that you're the photographer. Your camera is only a tool. Despite popular belief, there is very little hocus pocus involved in getting good exposures. You make the decision to record things as you see them, or as you'd like to see them. Take the time to learn the tonal system and those decisions will come more quickly. Being able to predict proper exposure has a down side—it takes a lot of the exciting suspense out of slide processing—but that kind of suspense you don't really need.

Light and Flash

The biodiversity of bog life captivates me. So when a friend found a yellow-bellied flycatcher nest built into a sphagnum hummock in a favorite bog, I was absolutely delighted. I just had to try to photograph this scene. I knew it would take a few days to move my blind and equipment close enough. But there was another challenge: It was a very dark setting. The nest opened at ground level and was tucked back into the roots of an old stump, surrounded by sphagnum moss, under a thick canopy of tree leaves and needles. There just wasn't enough light.

Where does light fit into the photographic equation? Well, you wouldn't have an equation without it. No photograph happens without light. Nature photographers have a strong preference for natural, or *ambient*, light and an even stronger preference for diffused ambient

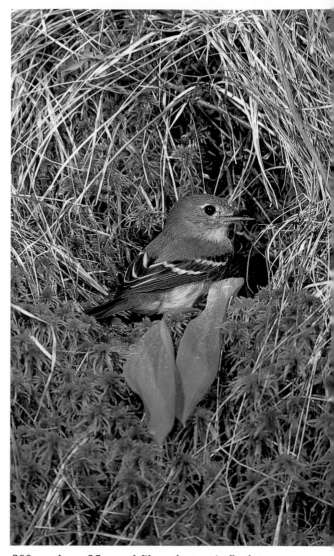

300mm lens, 25-speed film, electronic flash, 60th of a second, f/11.
A yellow-bellied flycatcher nest tucked into a tangle of roots in a sphagnum bog. The scene required total flash—there would be no hope of relying on natural light. I took lots of time setting up my equipment, testing to see if the bird would be comfortable with the presence of the photographic blind and flash equipment. For this photo I used a standard two-flash setup, placing my main flash at a 45-degree angle and a fill flash near the camera axis.

69

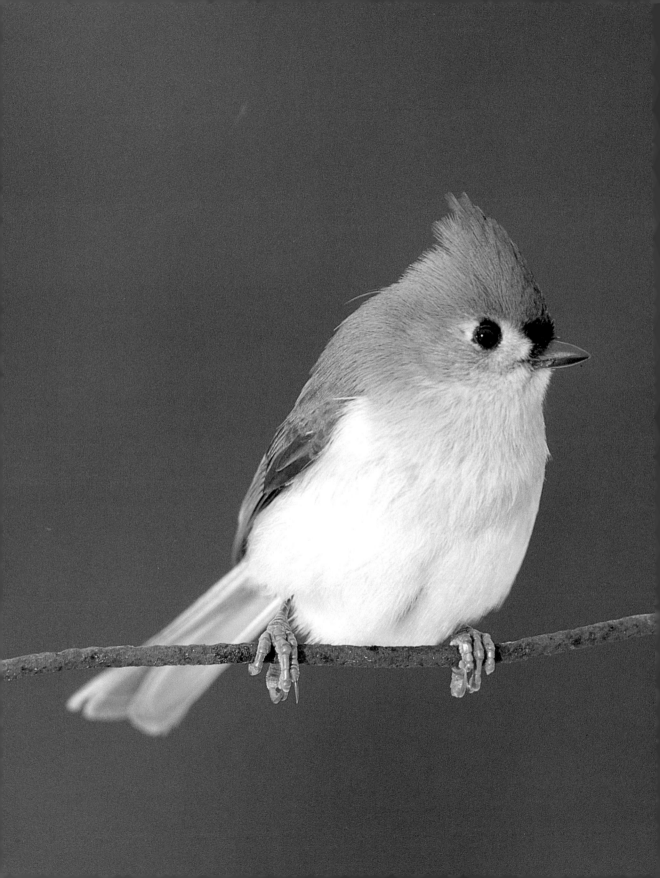

light, the sort we get on cloudy, bright days. Direct light from the sun or any artificial source can produce hard lines and shadows, brighter brights and darker darks. We call this high-contrast light. This light brings out a wide range of tonalities, often a wider range than can be recorded on color slide film. Diffused light helps soften that contrast, revealing the rich colors and fine details of bird plumages.

Most bird photographs are made using ambient light. But sometimes natural light just isn't enough to get the picture, like when you're photographing nocturnal species, or when the rising sun shines toward you, placing your subject in shadow, or when your subject inhabits a dark forest or bog, like my yellow-bellied flycatcher.

For times like these, if the subject will tolerate it, I use electronic flash to make the photograph. If after approaching the bird and triggering a flash I find that it upsets or scares away the bird, I realize that this bird in this setting can't be photographed. But I believe flash light mimics lightning in its speed and intensity, and I find that flash photography isn't any more or less upsetting to birds than photography without flash.

How Electronic Flash Works

An electronic flash delivers a very short, very bright flash of light. With many 35mm camera systems, the amount of light and the timing of the flash are cooperatively controlled by the flash and camera. Together the equipment works to synchronize the flash of light with the opening of the shutter so that the correct amount of light reaches the film plane to expose the subject correctly.

A flash's short, quick bursts of light travel,

In the dead light of a deeply overcast day, a weakened flash, or fill flash, put the light in the eye of this little tufted titmouse. It also brought out every feather, every detail in its feet, and every morsel of rust on its barbed-wire perch.

as you'd guess, at the speed of light, moving quickly forward and spreading out along the way. As the light spreads to cover more space, its power of illumination lessens. That is, the farther away the light, the more dim it becomes. We say the light "falls off." This movement of light happens in a very predictable pattern described by the *inverse square law*, which simply states that light will "fall off" to the square of the distance it travels. So if a flash illuminates a certain area one foot away, that same amount of illumination will spread out to cover four times the area, becoming four times less bright two feet away. The light will cover nine times the area and be nine times less bright three feet away, etc. So the farther we place our flash from our subject, the less intense the light will be as it bounces off the subject to record its image on film. The closer the flash, the more intense the light and the smaller we can make the aperture, giving us better depth of field.

Total Flash and Fill Flash

I'll distill flash photography to its two most general uses: total flash and fill flash. You're using total flash when you provide light brighter than the ambient light—the primary light used to record the photograph. You use fill flash to "fill in," lightening shadows or illuminating a backlit subject lit by a stronger light. Fill flash plays silent partner to the ambient light. Total flash swamps the ambient light.

Total Flash. I prefer total flash, or close-up flash, in situations where the subject and the background are more or less on a single plane. An ovenbird nesting on the ground, for instance, where you can light the whole area with one flash. Or I might use close-up flash in situations where there is a fairly close background, or a background I could easily light using a second flash unit.

The best thing about electronic through-the-lens (TTL) flash systems is they're so simple to use. There is a flash meter in your camera, and when you attach your electronic flash to your

71

camera and turn it on, this flash meter kicks in. Your camera tells your flash what speed of film you're using. You set your shutter speed to the flash-synch speed you need. You set the aperture you'd like, and you take your picture. The camera shuts the flash off as soon as it's given enough light for the aperture you've selected.

All you have to do is keep tonality in mind. Your camera and flash are still trying to record medium tonalities. So if your subject is light, and you want a literal translation, you'll want to use your camera's compensation dial to add one stop of light. If it's darker than medium, you should dial in a minus.

Fill Flash. I have a strong preference for fill flash. Fill flash photos give a nicely lit background and crisp detail in the foreground, along with a nice highlight in the eye of your subject. It gives you the best of both worlds, both flash and natural light photography.

When you use fill flash, remember, you will simply *fill in* the daylight. You'll add light to the ambient light already on the scene. That means you actually have to provide less light, one or two stops less, than is already being provided by the sun.

My flash makes fill flash easy. It automatically controls the fill and allows me to set the "fill ratio" I want. Then I just point and click. If I've selected a slower shutter speed, I have to be very careful to trip my shutter only when the bird is being still. If I don't, the flash will yield a crisp image of the bird in one position, and the ambient light will give me a soft image of the bird in a different position, producing a blurry halo or "ghosting" effect. In some cases the effect can be terribly artistic, but in general it isn't what I'm looking for.

If your flash has no dial-in compensation, you'll need to use your test figures or your flash's distance scale to see how far away you should place the flash. Let's say the ambient light reading gave you an aperture of f/8. Check your distance scale to see how far away your flash should be for an aperture reading of f/11 for one stop less light, or f/16 for two stops

less. Set your flash to manual and use a remote cord and stand to move the flash back to that distance. Or set it to the f/8 distance and fool it into giving you two stops less light by moving the camera's ISO setting to a setting two stops faster.

Equipment

My current flash is a Nikon SB-24. I use this off the camera at the end of two or three SC-17 flash cords, placing it up to ten feet away from my camera. This reach allows me to design the lighting for closer, softer, more natural light than I could get if I left my flash mounted directly on my camera.

I bought the SB-24 because it's simple to use, works well with my other equipment, and has all the features I'm looking for in a flash. It's smart, as some flash units are these days, and has through-the-lens (TTL) exposure-setting capabilities. It has rear-curtain synchronization and a flash-standby mode, which keeps my batteries from draining as I wait for birds to come in. It has easy-to-use compensation adjustment, and it's a nice, compact size.

Flash Synchronization

Most models of our chosen camera format, the 35mm, limit the shutter speeds that can be used with flash attachments. These cameras can synchronize the flash with the shutter at relatively slow shutter speeds, like a 60th or a 125th, somewhere in that range. These speeds assure that the shutter will be completely open before the flash flashes. When the light in the photo is being supplied by the flash, the speed of the flash (a 500th of a second to a 100,000th of a second) becomes the effective shutter speed.

The fastest synchronization speeds, or "synch," that I've seen in a 35mm camera is a 250th of a second. I use these high synch speeds to work in bright ambient light when trying to fill in shadows on an otherwise well-lit scene.

Many cameras will not allow you to use TTL

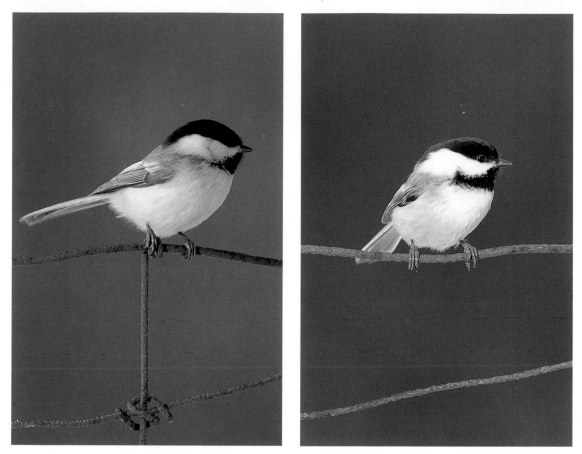

400mm lens with 12mm extension tube, 100-speed film, 30th of a second, f/11, fill flash set for -2 exposure.
Left: a black-capped chickadee in the straight natural light. Unless the sun is at precisely the right angle, the eye seems to disappear into the bird's cap. Right: the same bird, in the same situation, with a two-stops-weaker fill flash bringing out the eyes and the sparkle and wetness of the scene.

electronic flash at shutter speeds slower than a 60th. But some of the newer flashes do allow slower shutter speeds by various methods, including a feature called *rear-curtain synchronization*, during which the flash flashes at the end of the shutter trip instead of at the beginning, as it does with most units. If you're going to use fill flash in a versatile way, you'll want this feature in your flash.

Softening the Light

I may occasionally use artificial light to make my photographs, but I certainly don't want my photographs to *look* artificially lit. In order to get the most natural-looking light in a total flash situation, you'll need to pay attention to the size of your flash, where you place it, and whether you'll use its light directly or indirectly to light your subject. A larger flash up close will give you more diffused, natural-looking light.

When I use the flash as the main light source, I add a mini-softbox. The softbox is a wonderful tool for enlarging and somewhat diffusing my main light source. This gives softer edges to shadows and closely resembles the light of

cloudy, bright days. I've also seen some nice results from very powerful flashes used with bounce umbrellas.

When the Back Goes Black

The thing about flash light is, it's fast. It lights fast, and it falls off fast. So fast, in fact, that your daytime photos can easily look like night. Say, for instance, you expose a photograph of a nuthatch climbing a tree trunk. The bird is in profile, and the background is pretty far away. If you use straight flash at the proper setting to give you nice detail in the bird and the bark of the tree, that light will fall off very quickly, long before it gets to the background. So what you'll get is an inky black background—not at all natural looking, unless you're photographing a normally nocturnal species.

It's really a problem of tonalities. Let's say you had a medium background fairly close behind the nuthatch's tree, perhaps two feet behind the tree. Your flash is two feet in front of your subject and your exposure is set so that a medium tone at the plane of the nuthatch would be recorded as a medium. Two feet back, at twice the distance, with the light dropping off at the square of the distance, would place a medium subject two stops darker, to very dark, on the edge of black. Conversely, any medium-toned foliage or obstruction a foot in front of the subject would appear very light on your slide. For one solution to this problem, see Fill flash, page 72.

The Light of Their Eyes

We live on a planet that has just one sun. That one sun places one highlight in each of our eyes. One spark. We're used to seeing each other and the animals around us with one spark in each eye. Keep this in mind when setting up flash for any kind of photography involving a subject with eyes, and set up your flashes to allow only one highlight per orb.

Sometimes you can get naturally occurring multiple highlights in the eyes, especially on water birds, which have one highlight from the

sun and another from the sun reflecting off the water. When you see this, something registers as wrong, or at least not right. I usually design lighting arrangements so that only one light comes from the front. That may be a softbox or a low-level fill flash. What you choose will also affect the size of the highlight in the eyes. You'll want to keep your flash at a distance that will give the same size highlight that the sun would if you were using natural light. Not too close, not too far. Because different flashes have different sized reflectors, I can't tell you what that distance is. Knowing where to place your flash to deliver a just-right highlight with your equipment will take some test frames. Somewhere in the neighborhood of two to four feet should give you a good starting distance.

Of course there are exceptions to every rule. If you're photographing hummingbirds and you want to show off their remarkable iridescence, you'll want several lights to shine on the bird from different angles, and you'll have to put up with the cluster of highlights in their eyes.

Test Your Flash

Before buying a flash unit or using the one you have, you should know precisely what that unit is capable of doing for you. The best way to do this is to test it yourself, particularly if you're working with manual (rather than TTL) flashes, where you need to know precisely what apertures you'll need to use that flash at various distances. All of my lighting solutions can be done with manual flash. Run some exposure tests to determine the proper flash distances for given f-stops, then work with the flash at those measured distances.

Flashes Afield

In the old days I used a two-light flash setup for nest photography, just like everybody else. (That's how I got the yellow-bellied flycatcher photograph on page 69.) My friend and I put one flash at a 45-degree angle from the front of the nest and used a second flash, two stops

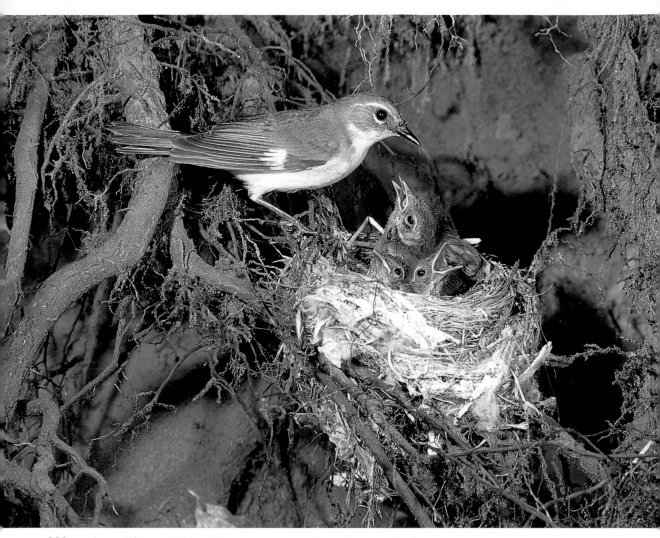

200mm lens, 25-speed film, 60th of a second, f/11, electronic flash.
The black-throated blue warbler nest required a total flash setup. Standard two-light setups are great for providing all the light you need, but the result will usually produce a double highlight in the eyes.

weaker, at camera level to light the shadows created by the first flash.) Sometimes I'd add a third light to backlight the birds. All of these lights and cables and exposure computations got pretty complicated and took a long time to set up.

That was then. Now I take a simpler, more natural approach. I still use two lights on occasion. I carry one flash and a five-by-eight

softbox, off-camera flash cords, and a Bogen Superclamp with a Kirk long-arm. I can reconfigure this simple, easy-to-carry outfit into three very useful systems:

Fill Flash. I especially like fill flash when the light on the bird is very flat and there is no ambient light highlight in the eye but the background is nicely lit, or very beautifully lit—at sunrise or sunset for example.

The daylight needs to be bright enough to allow a shutter speed in the 8th to 30th of a second range or faster, and the bird needs to be still at the moment of exposure. The only highlight on the eye with this setup comes from the fill flash, which I place at a distance that produces a sun-sized highlight. I prefer the effect I get when my flash is one to two stops weaker than the natural light, or −2. On the SB-24, I

200mm macro lens, 100-speed film, auto-fill flash, remote release, 125th of a second, f/11. These house wrens, like most of their species, were indifferent to my comings and goings as I set up my camera. The natural lighting came from behind the setting, so I used fill flash to open up the foreground. I then activated the shutter by remote control from some thirty feet away each time the birds came to the nest entrance.

dial in compensation right on the flash. Then I meter the scene in manual mode with the flash set for rear-curtain synchronization. The exposure runs its course, and just before the shutter curtain closes, the flash flashes, adding sparkle to the scene and a highlight in my bird's eye.

Softbox Close Up. I use a flash with a softbox in low light where I have to deal with subject movement but the subject and its background are all essentially on one plane. The larger light source softens any hard edges that would have resulted from using the flash alone.

I clamp my flash into the softbox, mount it on an extra tripod, and place it close to the bird or nest, at about 30 degrees above the lens axis and about two feet away. I set the shutter speed to my maximum synchronization speed, a 250th of a second. If I'm using 100 ISO film, I place my aperture at f/11 for good depth of field and full action-stopping speed with the flash. I can photograph a lot of motion with

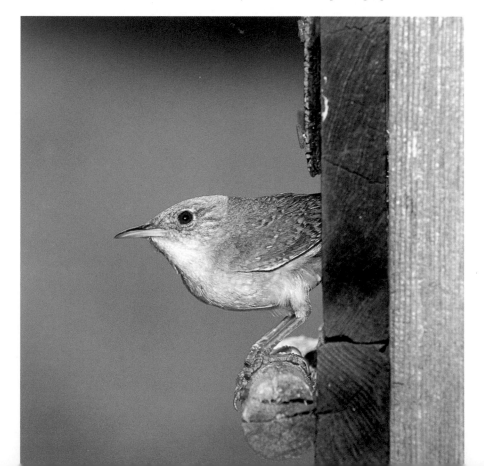

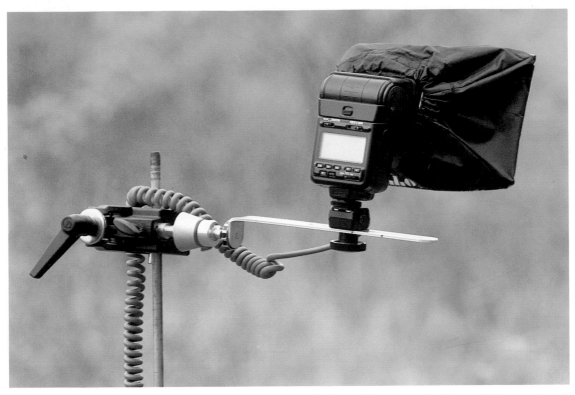

Here is my softbox setup. I mount the softbox on my flash and clamp my flash to a light stand so I can position it wherever I please. I generally point it to light my subject at a 30-degree angle and place the shadows behind my subject.

this setup. If I use it in the right places, like that bog with the flycatcher's nest I described earlier, it gives me very nice open light.

Softbox plus Natural Light. But sometimes I want to use softbox flash in a setting that will create shadows, or when I might lose the background completely if I'm not careful. As long as I'm working with a subject that stays still for short periods of time, this works great. In this way the softbox provides the main light, but the shutter is open long enough to allow the weaker natural light to "fill in" the shadows or distant background. In this case, I set the shutter speed for ambient light exposure, one stop weaker than the flash. For example, I have my lens aperture set to f/11 and my flash compensation dial set at 0. I meter the scene in manual. Let's say I get a 15th of a second at the f/11 aperture I've chosen. I then speed up the shutter by one stop to a 30th.

Photographing Birds

- Where do you find birds?
- How should you approach them?
- How do you use a blind?
- How do you photograph flight?

In *The House at Pooh Corner*, Christopher Robin tells his good friend Winnie the Pooh that what he loves doing best is nothing. I'll buy that. When asked where I'm going and what I'm going to do, my favorite response is "Nowhere and nothing," and then I go and do it, with a passion. Sometimes nothing keeps me busy for days. Sometimes nothing exhausts me.

We people have pushed ourselves farther and farther from the wild. In so doing we've pushed something of ourselves away. For most of us, what's missing is that ability to do nothing in a very productive way. That's the best advertisement for the hobby of nature photography I can think of: It's the best way to do nothing and still end up with something. That something might be a great memory, an interesting discovery, a wonderful photograph, or a better outlook on the world.

Now, when we add birds to this nothing-doing equation, we add a sense of mystery and wonder. We contemplate raw instinct, the marvelous link between function and beauty. These mesmerizing qualities are what keep bird photographers on the job, sitting still in a frozen blind, or up to their armpits in swamp water hour after hour, day after day, with no sense of passing time, with nothing on their minds but their subjects as they watch and wait.

Watching and waiting calls all your senses into play. You soon see that every little wood lot is an intricate wilderness. You hear the sounds of birds and insects, smell forest loam, meadow grasses, minnow ponds, feel the sensuous touch of breezes blowing through the blind—this is a marvelous way to live.

To enjoy photographing birds, you need to know how, when, and where to approach them, in a manner that is safe for both you and the animal.

Low-impact Photography

The late great British bird photographer Eric Hosking told how he once found the nest of a goldcrest that contained the egg of a European cuckoo, a parasitic species. He had visions of photographing the tiny nest filled to the brim with the giant cuckoo chick while the petite goldcrest labored to feed it. When he thought the eggs had hatched, he returned to find the

400mm lens, 100-speed film, 250th of a second, f/5.6.
Southern Florida is most certainly a birder's paradise, especially in the nature preserves, where for the most part the birds remain approachable. This white ibis on Sanibel Island, in the Ding Darling nature preserve, allowed me to approach close enough to gather a sparkling portrait.

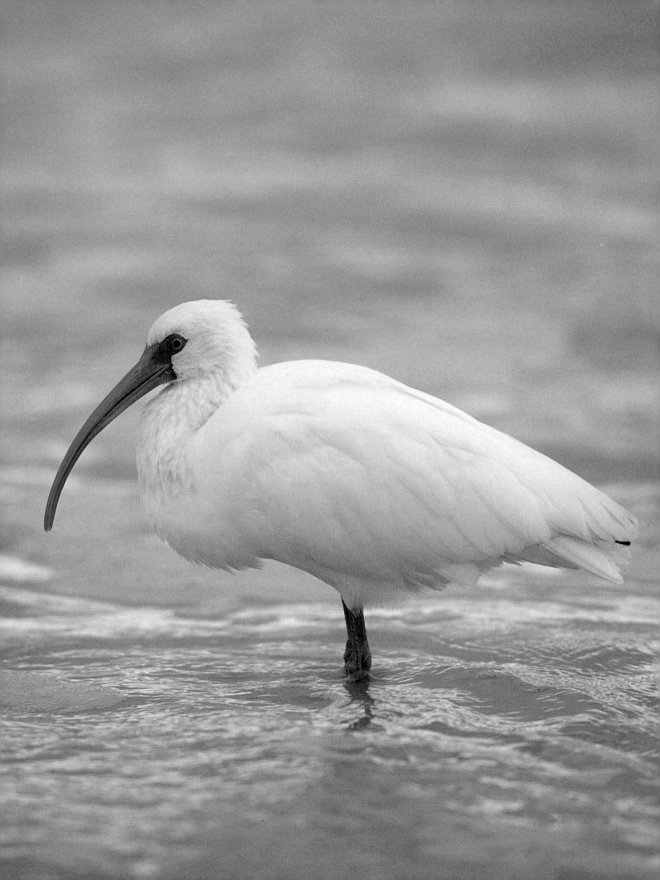

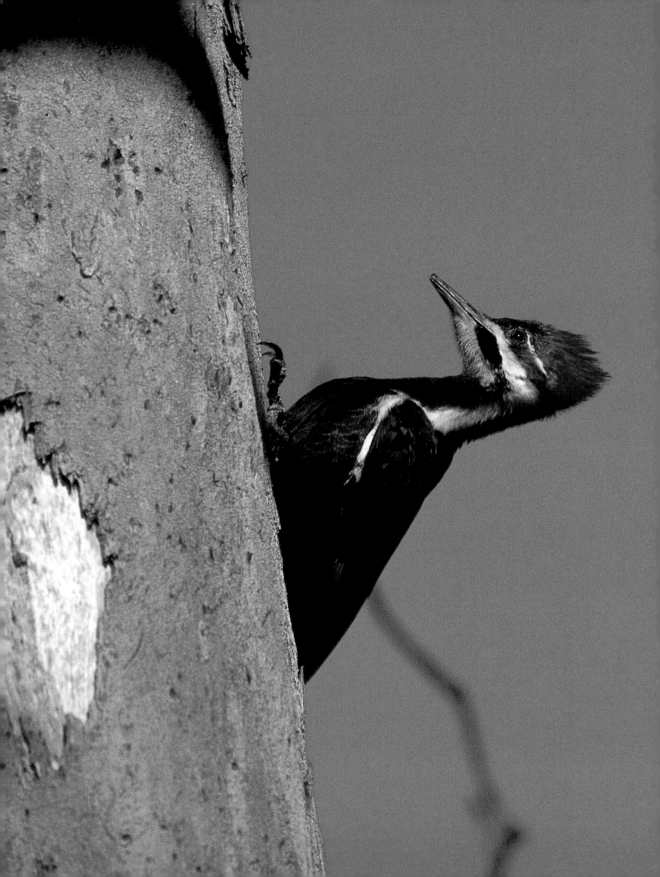

entire nest neatly snipped off the tree, probably at the hand of egg collectors. Egg collecting was a common hobby at the turn of the century. There are those among us who knowingly or unknowingly have a similar effect on birds as did those egg collectors of old. Hosking would roll over in his grave if he knew some of the things that go on today in the name of getting a picture.

I said in the first pages of this book that I advocate a *low-impact* method of photography. I would like to advocate a *no-impact* method, if such a method were possible. The fact is, every time we take a step, we leave our mark. We are always making an impact, just as a raccoon does, or a deer, or a bird. If we're aware and intelligent about our approach to wild lands, our impact won't be any greater than that of any wild mammal.

Unfortunately, we're not always aware. Breaches in intelligence abound and have given rise to a great deal of discussion and the call for a standard code of ethics among nature photographers.

In 1989 Jeff Foott, a well-known and well-regarded nature photographer, initiated a consciousness-raising forum for the discussion of ethics in *Outdoor Photography* magazine. Though not the first of these discussions, it was one of the most prominent. During the past few years, the concern has echoed through virtually every magazine and newsletter in the nature press. Various photographic groups have published codes and guidelines of acceptable behaviors and etiquette for professional and hobbyist nature photographers. In addition, our state and national parks contemplate

400mm lens with 2X multiplier, 100-speed film, 250th of a second, f/8.
Being a low-impact photographer means always respecting the bird's need for safety. This pileated woodpecker was nesting in a mini mall and was not at all threatened by my presence.

regulations that would restrict the activities of nature photographers.

I would have never dreamed thirty-five years ago, when I began my career, that the world would spend any time at all talking about nature photographers, much less worrying about what kind of impact we have on the environment, or how well we get along with others who are trying to enjoy the same animals, views, and habitats. Thirty years ago, very few people were interested in nature photography. Today hundreds of thousands of hobbyists and professionals hit the nature preserves on weekends and all week long to photograph and enjoy wild creatures and wild places.

Unfortunately, some of them have muddled priorities. They've placed the importance of the photograph before the safety of the subject, and even before their own or other people's safety and enjoyment.

Does the world need another nesting meadowlark photograph at the expense of the brood? Certainly not. We have many beautiful examples of these photographs around to learn from and enjoy. Yet we hear the story of the overexcited photographer who clears away the brush and tall weeds around the meadowlark nest to photograph the young chicks. When the photographer leaves and the sun comes out, the unprotected chicks are broiled. Or the story of the photographer who sets up equipment in the path of other photographers or birders already enjoying the scene, approaching too close and scaring the subject away. There is the photographer guilty of harassment, who repeatedly lures birds away from their nests and feeding activities to defend their territories against a tape-recorded screech owl. Or the story of the photographer who captures birds to photograph in a basement aviary.

These are stories of the vast minority, the unenlightened few. But their lesser numbers don't make them less dangerous. Their behaviors and actions are steadily degrading habitats, endangering or frightening animals, and

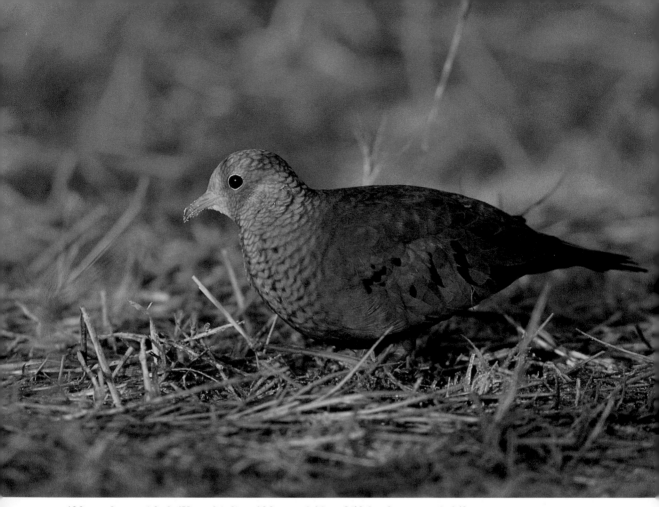

400mm lens with 1.4X multiplier, 100-speed film, 250th of a second, f/8.
Most doves require plenty of space. For this ground dove photo, I allowed a good working distance between me and the bird by using the longest optics I could.

breeding suspicion among park officials and lawmakers. Action by action they ruin the fun for everybody.

If you will take only one suggestion from this book, I hope it will be this one: Concern yourself above all things with the birds' well-being. The lure of a great photograph is strong. The temptation to tweak the world to suit your photographic tastes is powerful. But if you always keep the welfare of the subject and its environment your top priority, you won't go wrong. To help in your understanding, here's a short list of dos and don'ts I pass on to the folks who attend my workshops.

Don'ts

Don't harass birds. Learn to interpret bird behavior so you know when you are or are not upsetting their routine.

Don't cut away branches or foliage around bird nests. If you must photograph nests, look for ones that require minimal disruption.

Don't use tapes to lure birds, especially during nesting season—particularly tapes of predators, which with repeated use may cause birds to vacate the territory.

Don't try to photograph any endangered species, unless you're accompanied by a biologist. It's just not worth any harassment that could result.

Dos

Do use equipment, particularly optics and blinds, that will allow the least intrusion into birdlife.

Do understand all you can about the birds you are photographing, then take their habits into consideration when photographing them.

Do take some time to assist less knowledgeable birders and photographers by sharing your knowledge of the animal you are photographing.

Do assume responsibility for your actions, and think ahead of time about possible consequences.

Do slow down. Photographing birds takes time. The more driven you are to achieve results, the more tempted you will be to take shortcuts. If you don't have ample time for this hobby, find another hobby.

Getting Close

Throughout the centuries, the "human form divine" has captivated and inspired artists, poets, and philosophers. But at the sight of a human being, where Leonardo saw perfection and Blake sensed peace, most birds don't.

When birds see humans, as far as we can tell, they see a threatening profile, a predatory form. Those of us who enjoy getting close to birds must "break form." There are two ways to make our human profile more invisible to birds: stalking and concealment.

Stalking

Wild birds vary in their wildness, and in their wariness. Nevertheless, it's generally accepted that—except in extremely birdy public places,

in nature preserves where animals are used to human presence, or in the most remote arctic regions, where humans are an unusual sight— it's almost impossible to stalk wild birds. I've had my best luck stalking some very tame backyard species, some Florida shorebirds, the more common species of ducks and herons, and sometimes birds of prey, like ospreys, that nest in fairly public settings.

Successful stalking masks the human form, because in stalking you move differently than

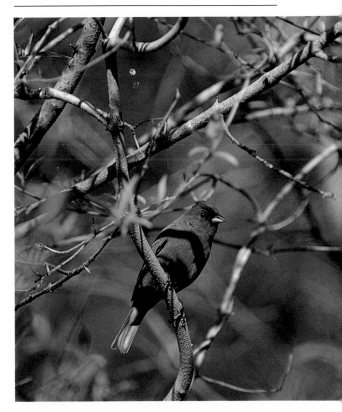

300mm lens with 1.4X multiplier, 64-speed film, 125th of a second, f/8.
Providing food and water for backyard-visiting birds is perfectly legitimate, provided you are consistent in your offering. This indigo bunting was attracted to my backyard by the natural water and food supplies that occur there. In this case, I simply picked up the camera and pointed.

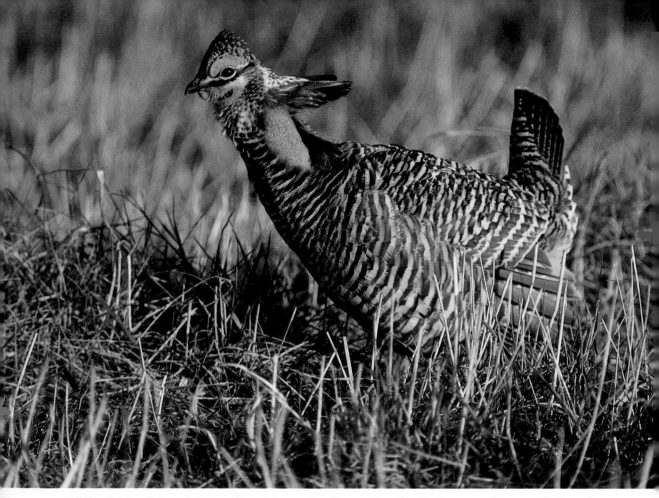

While visiting Colorado's San Juan Mountains, I was taken by the large nesting population of white-crowned sparrows. They were incredibly tame. One sparrow always perched on the same cornhusk lily about thirty feet from its nest. I stood near the perch and waited. The bird took no notice of me as it flew back and forth to the nest with moths and other morsels.

humans usually do. You move more slowly and come at your bird from a different angle. I don't subscribe to the notion that you must dress in camouflage or hide behind a bush when stalking birds. Birds are sensitive critters, and it's likely that they'll see you long before you see them. I've had my best success in stalking by remaining in the open, where my subject and I can keep an eye on each other. As I move closer, very slowly and in increments, the animal has a chance to adjust to my presence. And I can more easily determine if my presence is too alarming for it.

When stalking, I like to carry only the equip-ment I need for that situation, leaving my camera bag and other stuff behind. I don't want to fish around in bags, or rearrange my equipment, or add any movement that is not absolutely necessary. That also means I don't slap mosquitoes, sip coffee, or blow my nose. It isn't easy. We're a twitchy species, so this takes concentration and practice.

I approach birds, and any stalkable subject, by making small forward movements along a zigzag path so I don't appear to be approaching head-on, as a predator would. I move very slowly, watching my subject out of the corner of my eye. If the bird begins to look agitated,

I simply stop and wait. I wait for it to settle down, become comfortable, and begin to engage itself in some activity other than watching me. I do tend to expose a few frames before I've reached my ideal distance, partly to let the animal feel comfortable with these sounds coming from my direction, and partly because each photograph at each closer distance may be the closest I'll ever get to that bird.

One tough, ethical Catch-22: The easiest time to stalk wild birds is in the spring, when they're migrating and far too exhausted to focus on anything but finding food and resting. Many are too tired and have little extra energy for warily flying off, but that doesn't mean that your approach isn't causing stress. For this reason, at any season you should use the best and longest optics you can to allow birds a comfortable distance.

Concealment

The spring courtship dance of the greater prairie chicken—here's a photograph I prize as much for the memory of camping in my blind alongside a photographer friend of mine as for the rich hues of the bird and the remarkable behavior recorded here. When I see this bird, I think of stiff shoulders and damp clothes—a happy combination for people like me. I think of the awe I felt, that I always feel, in witness-

500mm lens, 64-speed film, 125th of a second, f/5.6
One of the most amazing scenes in nature is the spring courtship dance of the greater prairie chicken. I've enjoyed several marvelous mornings on leks (their mating areas) taking prairie chicken photos from my blind.

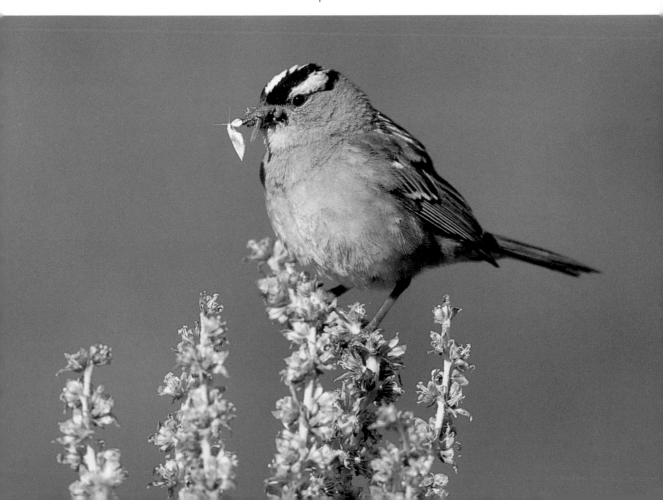

ing the dance. That feeling would have been impossible if I hadn't made myself invisible by erecting a blind.

The choice of most wild bird photographers is absolute concealment, disappearing into the environment or becoming part of it by stepping into a photography blind, or "hide," as our British counterparts would call it. Blind photography works best for bait-and-wait, backyard photos, wait-and-see "event" photography, and photographing at the nest. You need to know where the birds are going to be.

There are many ways to conceal yourself for work on the road, on the water, from your house, and in the field. There are loads of blinds on the market and an infinite variety that can be constructed through your imagina-

tion and ingenuity. But every blind I've seen or worked with fits into one of three categories: the frame blind, the permanent blind, and the "bag" blind. There is a fourth category worth mentioning: using something that isn't a blind as a blind, like an automobile or a screened-in porch, for instance.

Frame Blinds. Frame blinds are a boon to all wildlife photographers, providing a practical and economical alternative to permanent blinds with nearly all the advantages. Frame blinds are limited in size only by how much weight a photographer is willing to carry into the field, but they can be erected almost anywhere. Their only detractions are that they must be taken down at the end of the day or the season, they are easily stolen, and they are

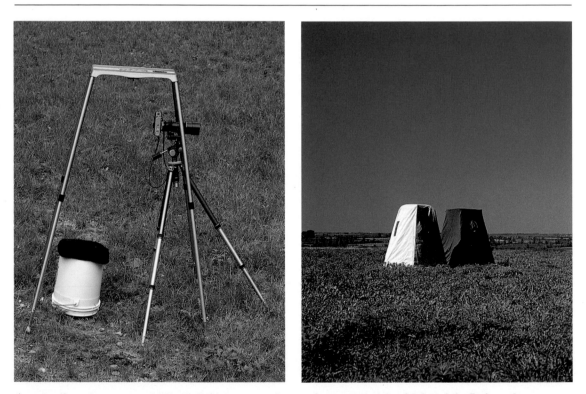

A pair of projector-stand blinds (left) set up a day early on a prairie chicken lek. Before dawn, John Shaw and I will climb into these and spend the morning as the birds come, dance, and go. I constructed my blind by placing a light cotton cover over a projector stand (right). The result is a light, sturdy blind that can be moved, though awkwardly, from the inside.

not as weatherproof as permanent blinds. The character and construction of frame blinds vary widely. They can be as simple as a make-shift umbrella-and-blanket contraption or as slick as one of the snazzy pop-up camouflage versions sold through wildlife photographic supply vendors (see Resources).

For years I worked from a structured, mov-able blind I constructed from a slide projector stand and olive-colored cotton fabric. Inside the erected blind I could move, albeit slowly and awkwardly, by picking up the stand's legs and my equipment and inching along, or rotat-ing for a better angle. This blind has been very useful, and quite sturdy for field photography, though it is a little too heavy for hiking far from my car.

Duck and marsh bird photographers can be thanked for working on many evolutions of the floating blind. These are usually some sort of frame blind mounted on an inner tube or other float sturdy enough to support equipment and photographer. The best I've seen was designed by photographer Keith Szafranski and con-structed of a flexible PVC crossbar frame at-tached to a fisherman's float tube with a ply-wood tripod-head support. Keith simply dons his chest-high waders, slips the float blind over his head, pulls his camera gear aboard, and walks out into the marsh.

Permanent Blinds. The permanent blind offers the most in comfort—an important com-modity for those of us whose enthusiasm is more sprightly than our joints. A permanent blind can be as large or small as you want or need, allowing plenty of room for equipment and supplies, for sitting or reclining, and for one or several partner photographers. Perma-nent blinds are ideal for photographing birds whose behavior and location are predictable. I've built permanent blinds in various places on my property. There's one I use to photograph songbirds at popular perches near my feeders. I have one from which I watch and photograph the wood ducks that nest in my wood duck boxes.

To photograph canopy-dwelling or high-nesting species you may need to build your blind on scaffolding, as photographers Powell and Betty Darling Cottrille did here.

I have constructed these heavy blinds of ply-wood and two-by-fours, with peepholes and a solid mount for my tripod head. I've fitted them with a comfortable bench and plenty of optional ventilation to help me balance inter-nal and external temperatures. My blinds are actually semipermanent, if you'd like to split hairs—they are too heavy to move on my own, but I can manage with one or two friends.

Bag Blinds. Late March in my backyard wood lot. The water, frozen all winter, has just opened up, and the wood ducks are on their way back. I sit on the bank of my pond to try out a new bag blind a friend has designed. It's partly supported by my broad-brimmed hat and partly by my tripod and long lens. Not

I keep two or three permanent or semipermanent blinds at strategic locations on my property, making them just big enough to hold me and my equipment. I've eliminated the complexity of a tripod by mounting my tripod head on the superstructure of the blind.

fifteen minutes after I climb inside the blind, a kingfisher splashes into the water ten feet in front of me, taking a mud minnow. This is so exciting, I can hardly believe my luck. It happened too fast to get a photograph, but I feel smug inside, because I see this blind design is going to work very well. Over the next few days I get some beautiful photographs of the wood duck pairs that will nest on my property this season.

If I had to pick a favorite blind, the bag blind would win hands down. It's the simplest in construction—basically a whole lot of camouflage material with one hole for your camera lens and another for looking around. You place the bag blind over your body and your equipment to "disappear." With no unnatural edges, you might as well be another tree stump. The variations on this blind are as endless as for any other type. I love mine for its portability, its quick and simple setup, and its price.

The only drawback is its inability to mask movements, limiting your ability to handle photographic equipment. You have to plan your work ahead and be prepared with the proper tools.

There are plenty of choices in commercially made bag blinds. I lean toward designs that allow plenty of view, are made of a durable fabric that will breathe, and are roomy enough for both me and my equipment.

The Unblinds. The side of the road often holds some of the greatest photo opportunities. I used to drive right by them on a daily basis, until I noticed that when I pull off the road and

400mm lens with 1.4X multiplier, 100-speed film, 250th of a second, f/8.
The heart-stopping yellow plumage of the male American goldfinch is one of the heralds of spring for birders in the North. This fellow visited the thistle feeders in my backyard. After studying the habits of the birds visiting my backyard feeders, I placed my semipermanent blind facing a favorite "approach perch."

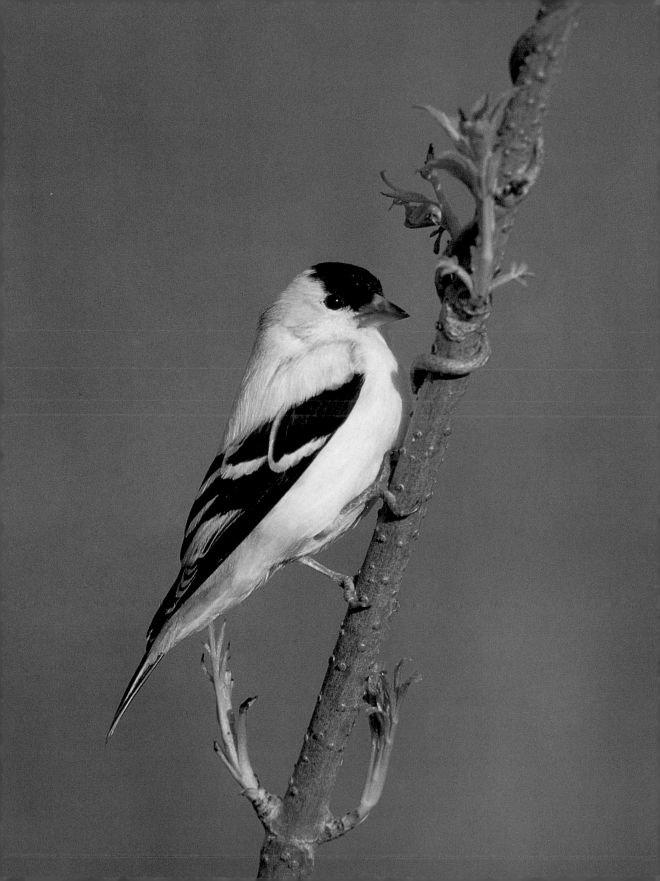

I've had remarkable luck photographing in comfort and style in Rod Planck's Invisiblind. *I like bag blinds like this one for their portability, ease of use, and organic shape.*

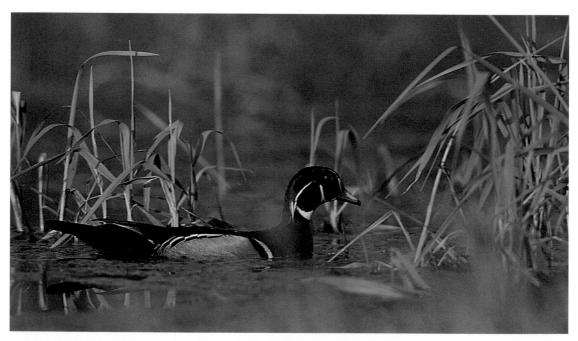

400mm lens with 2X multiplier, 100-speed film, 30th of a second, f/8.
In all my years of photographing, I've been unusually unlucky in photographing wood ducks, which live in my back woods flooded area during most of the year. Trying out my new bag blind one spring brought me this drake's photograph.

90

stay in my car, birds often do not fly or swim away.

There are lots of ways to conceal yourself and your movements when photographing birds that don't require investing time or money in standard photographic blinds. One of the most popular means is simply taking advantage of the comfort and sturdiness of your car or van.

It's easy as pie to drive your van into a field, open up the back or side door, drop a cloth to mask your movement, and photograph from an opening in the cloth. I never leave the driv-

er's side of my car. I simply set up my tripod on the passenger's seat, placing one of the legs in the coffee cup receptacle between the seats, one against the passenger's side door, and the third in the backseat. This setup keeps the

400mm lens with 1.4X multiplier, 100-speed film, 250th of a second, f/8.
Many birds are more comfortable in the presence of an automobile than of a human. I photographed this robin in late snow from the passenger's side of my car.

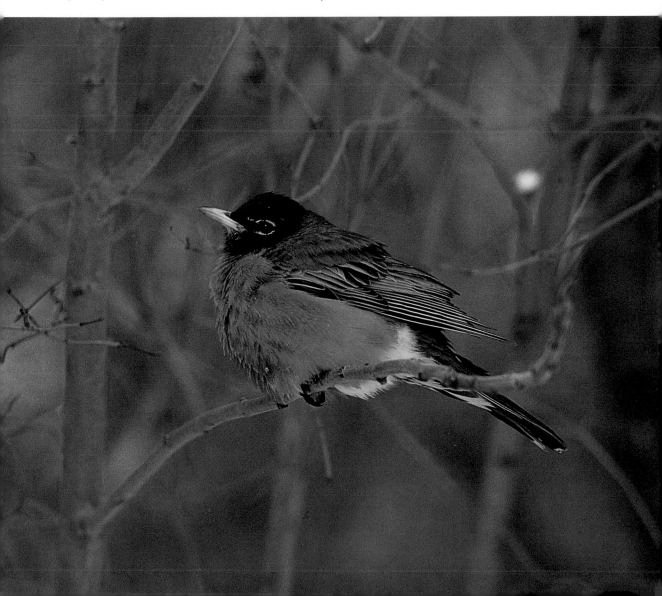

camera body close enough to me to be comfortable. The lens is slightly inside the door, protecting it from too much sun or rain, and I can pull off on the proper side of the road to stay out of traffic.

Window braces (see page 29) were developed especially for car-blind photography but can be adapted for house-blind photography very easily. Screened-in porches with views to favorite songbird perches, nests, or feeding grounds make wonderful permanent blinds. Put up sheets or netting of some kind to mask your movements at all but one window. Then replace the screen from that window with a slitted sheet or a sleeve-and-cuff construction and you've got a wonderful blind. One woman I know propped her back screen door open and draped a dark plastic dropcloth over the back of it to make a fabric lean-to she could sit in to monitor the progress of the swallow nest under her back eaves. It limited her family's traffic pattern, but they had long before learned to reroute traffic to accommodate her favorite pastime.

A refrigerator box makes a good temporary blind if you can find a way to weigh it down.

Building or Buying, What to Look For. I have photographed alongside many of this continent's best outdoor photographers. One constant in my travels is the realization that we all do things a bit differently. You and I will develop our own styles, have our own ideas of comfort, and tolerate different degrees of pain. (One friend stays still, on his stomach in a bag blind, for four to six hours at a spell. His wife comes to collect him at the end of the day, because by then he needs help to stand up.) My ideal blind is different from the next person's, and so far this blind exists only in my head. I redesign it with almost every trip, during years and years of sitting in the field, between birds, imagining what would make my life easier. For this reason I usually make my own blinds. I made and remade the projector-stand blind described above.

Whether you're building your own or buying, there are lots of features to think about or look for. Spend some time in someone else's blind. Note how much room you have and how much you need. Pay attention to what equipment needs to stay dry and whether you can store things within reach. Think about visibility, not just through your camera but all around you. Tiny peepholes have become obsolete with the development of camouflage netting and solar-screen fabric. Consider the light you need inside your blind for finding equipment, reading film speeds, finding your lunch. How much equipment do you use? One camera or two? A small folding chair with back support is important. Pockets in the sides of frame and bag blinds help hold the essentials. Add Velcro closures and zippers to save yourself time in packing up and moving.

What weather will you encounter? Roger Tory Peterson's hot-weather burlap designs would be great in many summer climates but terrible in a Costa Rican downpour. Gore-Tex would work in the Pacific Northwest in most seasons, but I wouldn't take it into the Everglades unless I had a lot of water weight to lose. For frame blinds I like good old cotton. It's not as waterproof as some other materials, but I don't make a lot of bird photographs in the rain. A permanent blind can be made of most any building material. In winter months, plan to dress for warmth. A heat source within the blind isn't a good idea, because heat escaping from the blind can produce heat shimmers that distort photographs.

Consider your camera's view. For bird photographs, the smaller the opening the better, be-

400mm lens with 1.4X multiplier, 100-speed film, 250th of a second, f/8.
I can count on one hand the number of times I've seen the red belly of a red-bellied woodpecker. It never fails: Every time I enter my backyard blinds, I come away with a deeper appreciation for the birds I've known all my life.

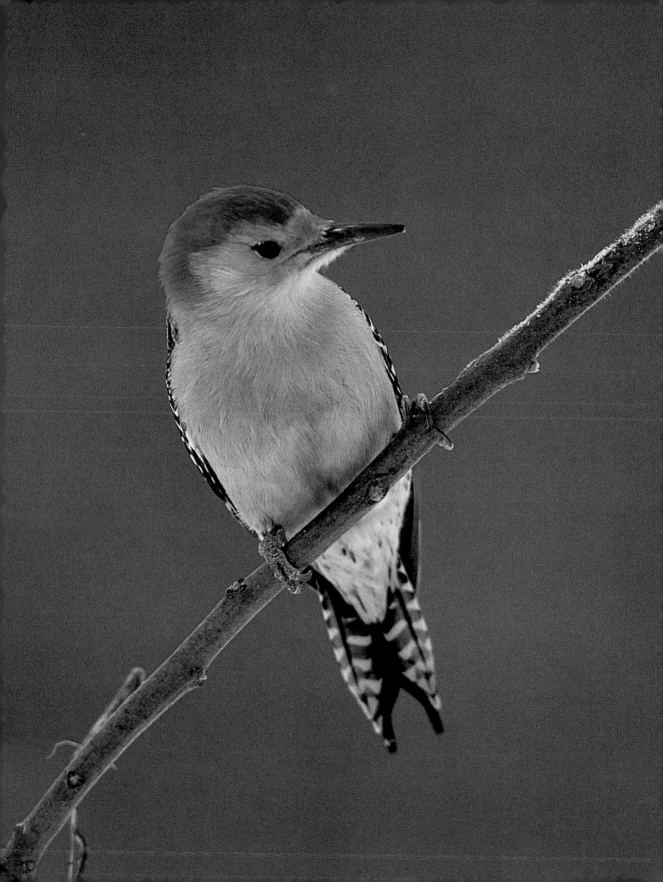

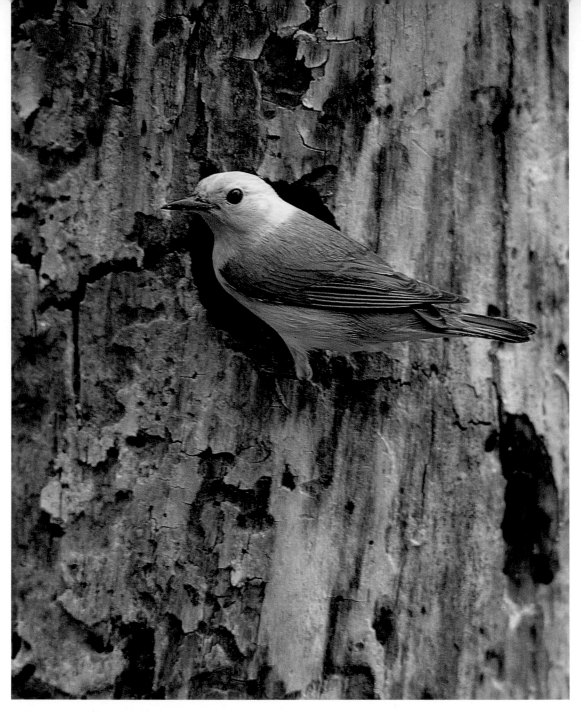

200mm lens, 25-speed film, 60th of a second, f/8.
The nest is the greatest center of bird activity, providing rich opportunity for photographing inter-
esting bird behavior but requiring great patience, planning, and care. I photographed this
prothonotary warbler at its nest cavity near a southern Michigan pond. To get the photo I spent
five days building a platform and erecting a blind, all the time ready to pack up and leave
if my presence, or the presence of the blind, seemed to upset the bird.

cause birds are particularly sensitive to sound and motion. I've seen blinds fitted with sleeves with Velcro slits, or cuffs, which allow movement and close snugly over any lens. The sleeve should be billowy enough so that if the blind moves in the wind, it doesn't move the camera equipment too.

Above all, be patient with the process. I have many blinds for different situations and have spent the better part of a lifetime adjusting, fine-tuning, reconsidering, and testing new possibilities. I guess I see it as part of the sport.

Nesting Birds

In the White Mountains of California, I stood photographing the bark of a bristlecone pine tree when a mountain chickadee entered a nesting cavity not ten feet from me. Five minutes later the bird's mate arrived, loaded down with a beakful of caterpillars. I continued to photograph my bark, and the birds concentrated on feeding their young. These birds were bold and totally ignored me. I calculated in my head: The nest opened under the deep shade of a pine tree, so I'd need flash. It was also very close to another tree, so I'd need a short lens to get in there, something around a 200mm to give me close working distance. To get a blind close enough to the nest to use a 200mm would take some time, at least three days. I didn't have three days, so I watched and enjoyed the birds from a distance and then left.

A bird's nest is a great center of activity. It's a place where birds are almost guaranteed to appear at certain times of the day, and during the past couple of decades bird photographers have taken advantage of this opportunity, primarily—many exclusively—photographing birds at or around their nests. Nest photography didn't seem such a bad system back in the 1940s, 50s, and 60s. But as more and more hobbyists took up nature photography and bird photography, we began to hear more and more reports of nest abandonment, predation, and other nest failures resulting from photographers' harassment.

With today's vastly advanced photographic technology, most bird photography now takes place away from the nest. It's much easier with today's faster equipment and infinitely faster film to capture images of birds at any of their many other fascinating behaviors.

At-the-nest Responsibility

Those who are still interested in nest photography must accept a great deal more responsibility. Here is where your photographer's ethics will tell. Birds are tied to their nests by their instinctive urge to care for their young. This pull works against their great fear of blinds and other foreign objects and sounds in their environment. The result of this conflict is stress. The stress may not be enough to force a bird to abandon its nest, but it is certainly enough to alter behavior.

My rule for nest photography is simple: If I cannot do low-impact photography, I don't photograph. Period. I won't photograph a nest that doesn't naturally provide me with a clear view. I won't remove vegetation around a nest. At most I might tie back a branch and replace it when I'm done, so that it continues to shade the nest and the nestlings. I never handle or move a nest or the eggs or nestlings in it. Essentially, I never let my desire for a photograph overwhelm my common sense. And I never give out the locations of nests I have found to other photographers, unless I am absolutely positive they'll be as careful in their approach as I would be.

I don't do much nest photography, but when I'm tempted, it's usually by a cavity nester. The cavity nesters on my property tend to be trusting, common species. The cavities are generally easier to photograph, with less foliage camouflaging the nest.

Planning the Approach

After finding a nest, I plan my approach. I tend to move my equipment into position over a period of three or more days. I always work with the longest lens I can for the situation and

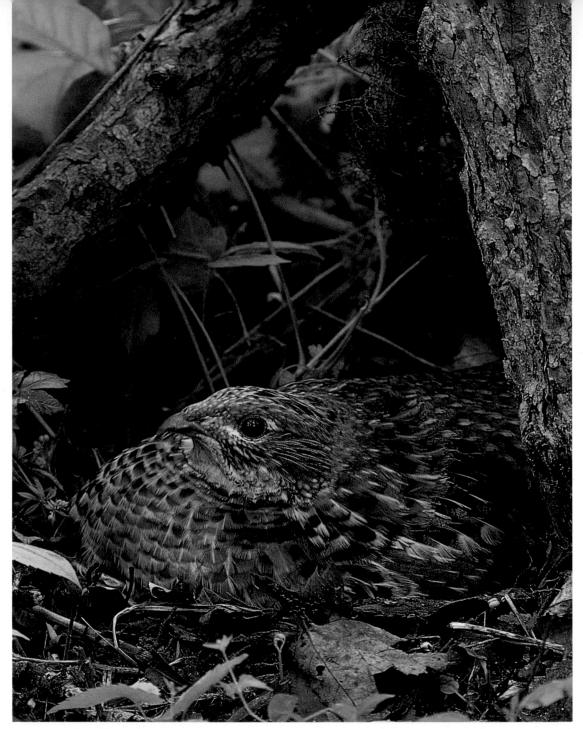

400mm lens, 25-speed film, 15 seconds, f/16.
This photograph was only possible because of the behavior recorded here. Part of the female
ruffed grouse's system for camouflaging herself and her nest is to remain completely motionless for
many seconds. I made this photograph under a dark forest canopy on a 25 ISO film with
a 15-second exposure.

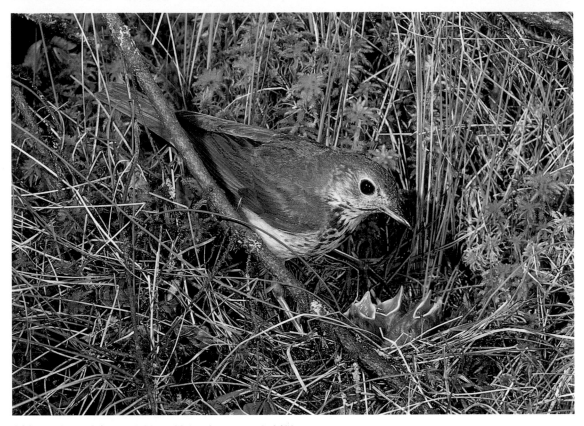

300mm lens, 25-speed film, 60th of a second, f/11.
Finding a nest is the first trick. But then begins the hard work of carefully planning the approach. I spent three days setting up to photograph this hermit thrush at its nest. It's a good idea to take extra time when using flash equipment.

prefer something in the 400mm to 600mm range to keep the blind farther back from the nest. On the first day I set the blind up at a distance of thirty-five to fifty feet, depending on the terrain and the wariness of the bird. The next day I move the blind forward to about fifteen to twenty feet. My projection-stand blind is nice for this purpose, because I can simply pick it up and move it without hassle. Obviously I work on my own property, or the property of someone I know, so I don't worry about losing the equipment to a thief. The third day I'll move the blind to a proper working distance. With a long lens, that means ten to fifteen feet for smaller birds. If the lens you're using requires a closer distance, take another day to move the blind into position. In places where a slow approach cannot be made, take several days to erect your blind, starting with parts of the frame, adding parts over a period of days.

Blinds tend to draw people, cattle, and horses, not necessarily in that order. If you are working in open land, try to choose a remote location out of sight of roads. In a cattle-occupied field, erect a fence around the blind to prevent your blind or you from being nudged over or trampled.

In the Blind
With the blind in position, you can now enter. I don't believe you can be overcautious in nest

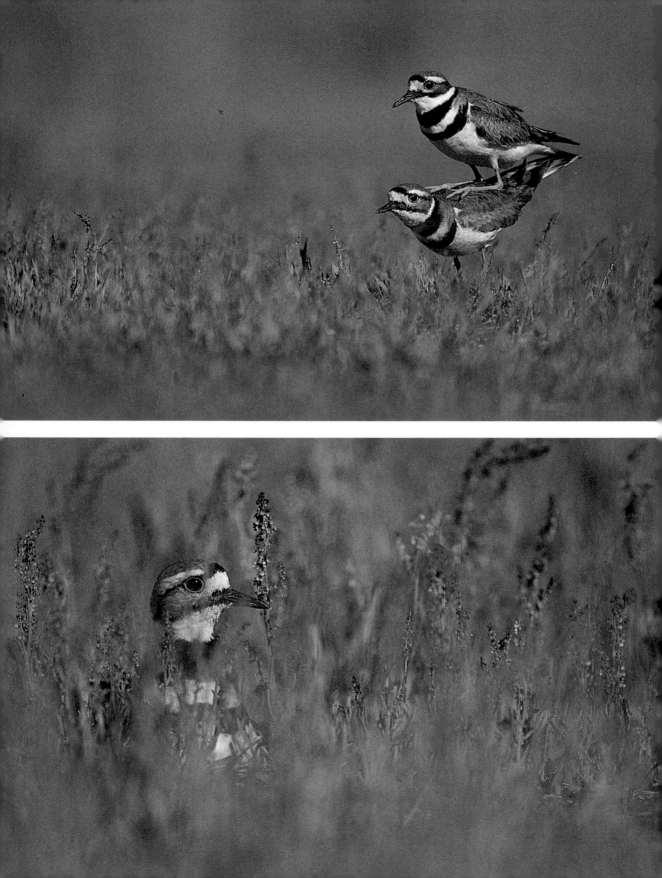

photography. If it is possible, then I hope I practice overcaution. I recommend overcautiousness to you too. I believe it's very important to the comfort of your subject for you to bring along another person as you enter the blind, so that person can go away after you've entered. The theory here is that birds and animals don't count. They see danger approach and they see danger leave. I believe this system gives you a much more calm, unstressed subject. I call this other person, usually a member of my family, my "go-awayster."

As soon as I enter the blind, I position my photographic equipment so that I can reach everything I need with no hassle. I train my lens on the nest, focus, and frame. I check the exposure often, so I'm ready if the light has changed. Then I wait, listen, and watch. Finally a bird returns to the nest. For this first visit, I will simply watch. I don't take pictures but give birds time to relax. That means I never make gross movements of the lens, and I don't make any sound within my blind. When I'm sure the birds have overcome suspicion, I make one frame. This usually startles my subjects, but not for long. When they settle down again, I might move the lens very slowly and smoothly, if my composition needs precise framing.

If the birds never settle down and look agitated or stressed the whole time, I abandon the project, pack up my equipment and blind, and

400mm lens with 1.4X multiplier, 100-speed film, 250th of a second, f/8.
Once in the blind, I've managed to mask my form only. A noisy blind can be just as upsetting as the human form. If you're quiet, you can watch birds at their most natural. I was photographing this incubating killdeer (top) when the mate came by. Completely unaware of my presence, the two began mating. Actually, the behavior here is a nonfertilizing, pair-bonding behavior they perform after eggs are laid.

go home. It's not worth the extra calories the bird is expending on my behalf.

When it's time to leave for the day, a come-and-getster (usually the same person as my go-awayster) comes for me. It would most certainly freak the birds out if I simply emerged from the blind. We have a generally agreed-upon time, and I've signaled to this person that I'm ready to be collected by hanging a white hankie outside a back flap of the blind.

Packing for Fieldwork

In-the-field photography is one of my favorite pastimes. Most people who take up the sport already have some experience with outdoor hobbies and understand that when you're enjoying the outdoors, it helps to be prepared for any find, any event, any weather.

The best way to be prepared is by preparing your mind. Know something about your destination. Be aware of poisonous plants, stinging insects and their habitats, which animals are approachable and which aren't. In nature preserves and sanctuaries, mind all posted signs. They were placed there by someone for a good reason, and bird photographers should take it upon themselves to lead by example, not bend the rules.

Some things that might be helpful when photographing afield: a compass, garbage bags, safety pins, self-adhesive Velcro strips, duct tape, plastic sheeting, sandpaper, clothespins, a pocketknife, a good bit of twine or wire, organic deterrent spray, a small first-aid kit, batteries, film, film, film, and whatever plastic bags or cloths you need to keep your equipment clean and dry.

Photographing Flight

There's nothing that says "gull" like a gull in flight, backlit by the sun, its head down, scanning for food, doing what a gull does all day long. Oh sure, you can take hundreds of frames of gulls standing on the beach hounding tourists for french fries. But for me a photo of a gull downing french fries doesn't invoke the sense

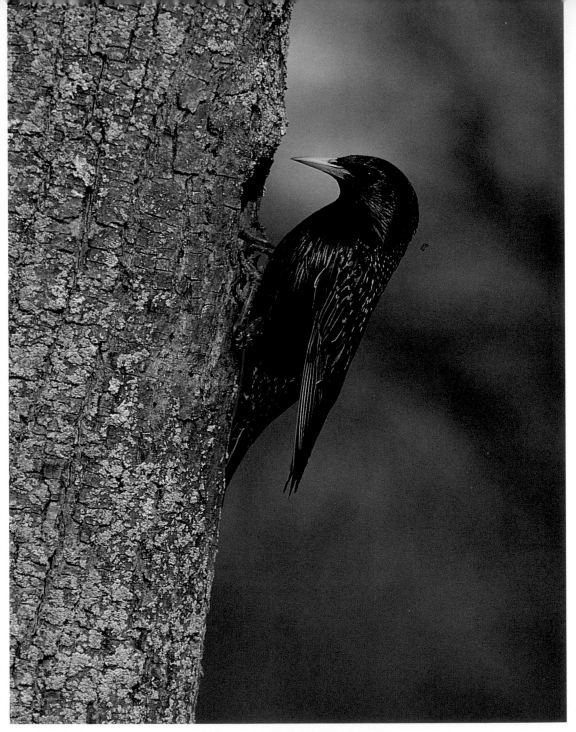

200mm macro lens with 1.4X multiplier, 100-speed film, freeze focus.
Birds are especially sensitive in the spring when exploring nest sites. In situations where the birds just can't tolerate my presence but seem not to mind my equipment, I will attach a remote to my camera or, as in this case, set my equipment for freeze focus and lock down the shutter release cable. Upon my return to this scene, I found an entire roll had been exposed.

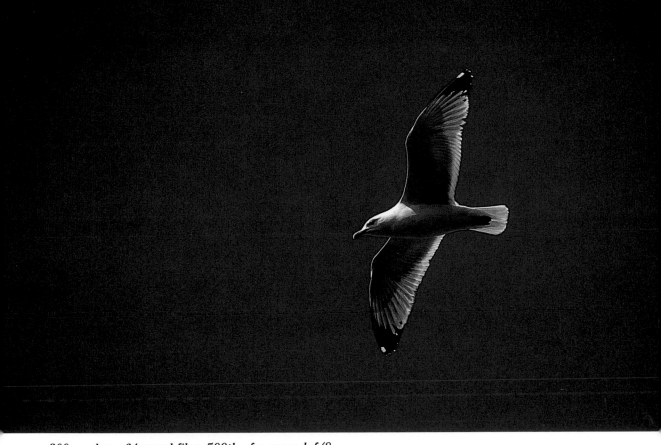

300mm lens, 64-speed film, 500th of a second, f/8.
One of my favorite flying gull photographs, taken with a 300mm lens at a 500th of a second.
I hand-held my equipment, panning to further stop the action of the bird's flight.

of raw survival and functional beauty that nature's greatest scavenger is capable of invoking. Jonathan Livingston Seagull is a flying bird. That's what I want in my photograph.

For many, many years, getting that perfect seagull photo was a frustration for me, because flying birds are awfully hard to photograph well. They move too fast; it's not easy to learn to point a 400mm lens and camera at the big, wide sky and find the bird in it, especially if you're hand-holding the equipment. Exposure on a backlit white bird is a little tricky, too. But then came auto-focus, and suddenly flying bird photography is ever so much easier. Suddenly I'm seeing frames of wild birds in magazines and calendars that twenty years ago could not have been taken. It's exciting. Because after

all, flight is one of the things we like best about birds.

Finding Flying Birds

Where do you find flying birds to photograph? Yes, in the sky, but to get successful images usually takes more than lying on your back in your yard and waiting for one to fly by.

So far I haven't seen many truly successful images of small bird species in flight, unless they were taken of controlled birds with high-speed electronic flash. As wild birds go, you'll do best to limit your birds-in-flight photo cravings to the larger species of water birds and raptors. At least while you're developing your flight-photo technique.

When you've chosen your subjects, the next

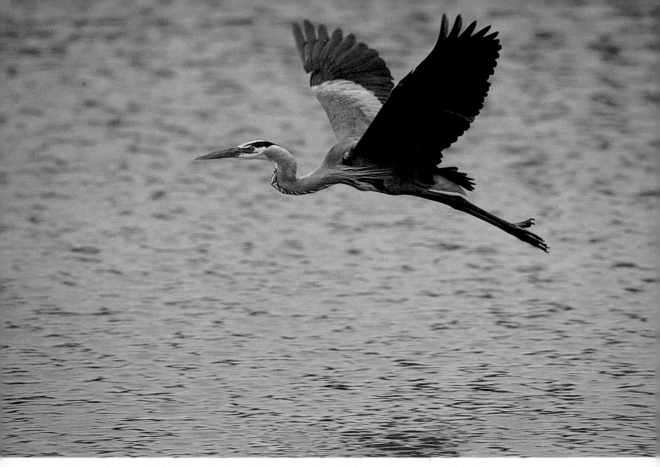

400mm lens with 1.4X multiplier, 100-speed film, 500th of a second, f/5.6.
My new camera's freeze focus capability makes a remarkable difference, allowing flight photos like this one. I preset my focus, then panned with this great blue heron. When the bird flew into my range of focus, the shutter tripped, and the result is a crisp record of one of North America's most beautiful fliers.

helpful thing to know is where you can find them and where you can position yourself to photograph them. Cliffs, mountains, dunes, and observation platforms make good vantage points. Anywhere your view can come closer to the birds'. If you can find such a spot where the sun is also at your back, practically assuring a front-lit bird, you're that much more likely to succeed. When you've found the place, go there a few times without your camera equipment and just watch. Where do the birds tend to come from? Which way do they head? At what times? In the Everglades National Park, the rangers can tell you exactly what time the ibises and spoonbills take off from one area in the park to go roost in another. That kind of information is like gold to a flight photographer. So ask around.

Equipment
Flight photos are usually taken from a fair distance. You want enough room in the photograph's frame to allow an interesting composition. Close-up flight photographs are interesting to a degree, but they give more a sense of bird anatomy than a feeling of flight. Personally, I like to see birds flying with plenty of airspace in front of them. It gives me the feeling that they're headed somewhere. I like that in birds.

When I'm out photographing, it's usually hours before I rest. So I like to mount my equipment on a tripod fitted with a Mono-ball positioned at eye level so I can easily track the movement of flying birds without wearing myself out.

A 300mm to 400mm lens is a nice size for larger flying birds. This range will bring them in close without overdoing it and without introducing problems of atmospheric interference.

When you've got a nice bird following a nice flight path, you absolutely won't want the extra job of advancing your film. You'll want as many successful frames as you can get of these few-and-far-between moments. Do invest in a motorized film advance if you want flying creatures.

Technique

You set your exposure long before the bird flies in. Use as fast a shutter speed as you can with the available light (though you will want as much depth of field as you can muster, particularly if the surrounding scenery is magnificent and helps to tell something about the bird's flight). Meter some surrounding subject that's sitting in the same light. Use the sky—or the sea, the meadow, the mountainside—and raise or lower stops to get a literal translation of the environment. Then you'll be ready for the bird when it comes. If you want to do some fine-tuning when it arrives, great. But readiness is everything for these photos.

The hardest part about these photos is not finding them or having your equipment there, nor is it exposing properly. The hardest part is getting a sharp image. Even gulls, which seem to hang in the air doing nothing in particular, are actually moving along at an awfully brisk pace. Auto-focus cameras and lenses and all their various focusing modes have eliminated this problem for photographers with the newer equipment. But even the most automated of bird photographers do well to know how we old-timers handled the problem.

We did it by *panning*, by moving the camera to freeze the motion of flying birds. Panning means following the motion of the bird by smoothly moving the camera, keeping your eye at the viewfinder, and smoothly, steadily refocusing the barrel of the lens while tripping the shutter button. The pan does not stop when you press the shutter but follows through well after the shutter has been released.

Practice the technique at sporting events. Runners and cyclists make good subjects, as do cars, boats, etc. Practice not only panning but also placing your subject where you want it in the composition.

Panning will allow you to use slower shutter speeds, but what you gain in depth may be lost in the blur of background you'll create during the pan. It's your choice. I like panning when I have a broad expanse of empty sky behind my bird. But a panned photograph can give the impression of mountains and trees whizzing by. Sometimes that's a better rendition of flight. Again, it's your choice.

Making a Good Photo Great

- What about content? Flow? Movement in the photograph?
- What about the graphics in photography?

Learning to See

I was standing around with a group of photographers along the drive at Ding Darling Wildlife Refuge, Sanibel Island, Florida. There wasn't much going on bird-wise when this pink feather floated by on a little puff of breeze. I had 560mm in lens combinations on my camera, and I meandered along behind the feather, photographing as I went. No one else noticed it or me. There was something about the cotton-candy color against the dull water that pleased me. It's a bird photograph without the bird—a trace of bird, a moment in time.

You can't plan compositions like these (unless you're going to stage them, which sort of defeats the point for me); they come along as they come along. But you have to be "tuned in and turned on" to your surroundings to notice, to see interesting bird events, and to know them for what they are. That takes practice. It means knowing birds very well. It means knowing the environment. It means being sensitive to juxtapositions, textures, mood. It means learning to see all over again.

Really, whenever you make a photograph, you're selecting a moment in time and space and isolating it in a frame. You're plucking it from reality, refining it, simplifying it, and presenting it on film. When you understand this, you begin to see in a different way. You see that a feather, a track, even bird droppings have

their places as interesting moments and strong photographic subjects.

Good light helps. I like to work in the rarer lights—earlier or later in the day, in fog, under overcast skies, when the sun breaks through a very dark sky, sunrises, sunsets, the light at the edge of storms—moments that aren't pedestrian, that offer more drama. As it happens, birds are most interesting at these times, and frankly, it's just a nice time to be alive, to be out and moving around in the world. When you feel good and alive and are breathing fresh air, you're much more likely to find beauty around you.

You don't need exotic birds to make great bird photographs. Any wild bird makes a terrific subject. But every bird needs its moment. It needs its best light, the best composition, its best season. If you can capture the bird at its best, you'll have a great photograph, whether it's a photograph of a robin, a tree sparrow, or a quetzal.

Knowing Your Subject

I'm not the world's greatest shorebird expert. I was on a fall photo excursion with my friend Rod Planck, and he spotted this Baird's sandpiper. Rod inhales field guides by night and photographs and watches nature by day. He lives in watery northern Michigan, so he knows shorebirds. He recognized this one as a Baird's. It was a new bird for me. Rod knew that it was on its autumn migratory flight and had traveled quite a distance from some far

400mm lens with 1.4X multiplier, 100-speed film, 250th of a second, f/8.
What makes a good bird photo? I like this translucent feather with its brilliant pink shaft against a background of murky water. Any birder could identify it as a roseate spoonbill photo, though there's no bird in sight.

northern tundra. He knew it was exhausted, looking for moths in the rubble along the beach. We stayed with the bird for hours, very quietly watching as it fed up and down the shoreline, coming close to us and our cameras, then moving away. We spent the entire afternoon photographing it.

I would never have this photograph if it weren't for Rod's knowledge of the bird. First of all, I might not have recognized it as special. Baird's are unusual birds in these parts and seldom approachable. I would likely not have known all that he knew of its habits, its biology, everything that makes a Baird's a Baird's. I know wood ducks, I know cardinals, I know great blue herons and red-winged blackbirds. I know a lot of birds, and I keep learning more.

When I learn a bird, I want to know a lot of things about it. I'd like to know what it looks like in its different plumages. I'd like to know when and how it molts. When does it breed? How does it attract or select a mate? Where and when does it build what sort of nest? How many eggs? What do the chicks look like? What does it eat? What eats it? How does it find its food? Where does it go in the winter? What does it sound like when it's staking out its territory, or when it's alarmed? What does it look like when it's comfortable, foraging, stressed? I'd like to know. I'd like to know how to distinguish the bird by its flight pattern.

Knowledge gives you power. Everybody knows that. If you know something about birds, it's easy for you to find them. You won't

go looking for great duck opportunities after lunch if you know the ducks are at their most active early in the morning and late in the day. If you know that barn swallows nest in the eaves of buildings, you'll know where to look if you want to photograph them. If you know to look at the base of trees for owl pellets, you'll

400mm lens with 1.4X multiplier, 100-speed film, 250th of a second, f/11.
Sometimes I don't know a good photo opportunity when I see one. Here's a photo that I would never have taken were it not for the superior shorebird knowledge of my birding companion. This Baird's sandpiper paused on a Michigan shoreline during its autumn flight from some northern tundra. We were lucky to see the bird, much less to photograph it—which we did until it had taken its fill of moths and contentedly flown off.

know how to find owl roosts for nighttime photography.

If I had known half of what Rod knew about the Baird's, I would have been ready. I can't help but think how many fabulous bird photo opportunities I miss because I don't know all my birds.

You get to know birds by devouring field guides and reading all you can about the natural history of birds. Read by night, go out and watch by day. Soon bird comings and goings will become as familiar and predictable to you as those of your neighbors or family.

The Decisive Moment

One day in southern Florida I was watching a red-shouldered hawk perched in a snaggy area on top of a low, vine-covered tree. It was just hunkered there in dull morning light. While I was watching, with the camera focused on it,

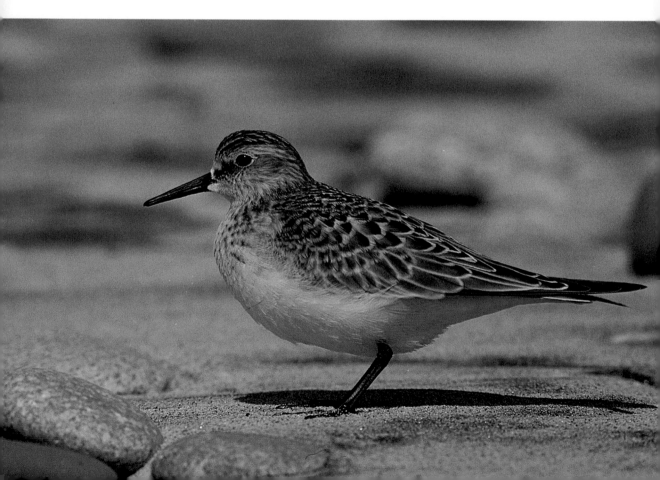

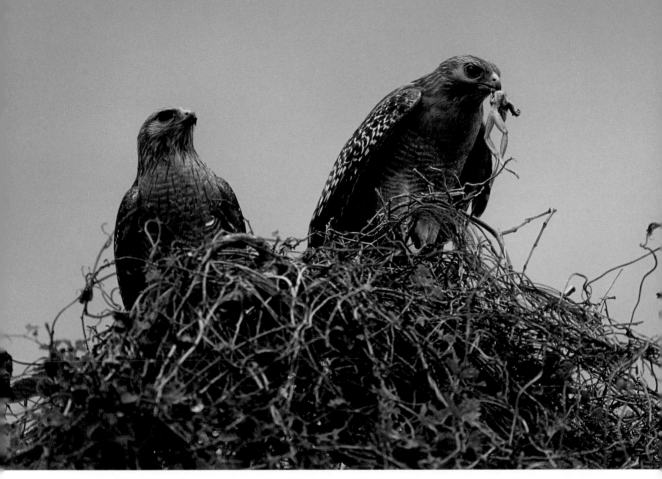

400mm lens with 1.4X multiplier, 100-speed film, 125th of a second, f/5.6.
The more time you spend in the field, the more likely you'll be to catch the rare photos. I had been watching one red-shouldered hawk, happily taking photos, when suddenly its mate flew in, bullfrog in tow. The two stood together for only a few seconds, enough time to get just two frames, before the moment was over.

another bird—probably the male—flew in with an enormous bullfrog in its beak. I was able to take a couple of frames before they flew off. The moment lasted only a few seconds, and if I'd been messing with my equipment or thumbing through a field guide, I would have missed it.

Your number of opportunities for great photographs is directly proportional to the time you spend outdoors photographing. You can't take photographs of great bird moments unless you're behind the camera, ready, when they

happen. You have to be ready for the decisive moment, when everything within the picture comes together. The pose, the lighting, everything. This may be one brief moment, when the bird turns its head a certain way, or yawns, or preens, and the action just makes the photograph. Or it may be when one ray of light breaks through the clouds and lights the water drops on a duck's bill. It's when the foreground and background make sense all of a sudden, when your composition is just so. It's when you have everything you need.

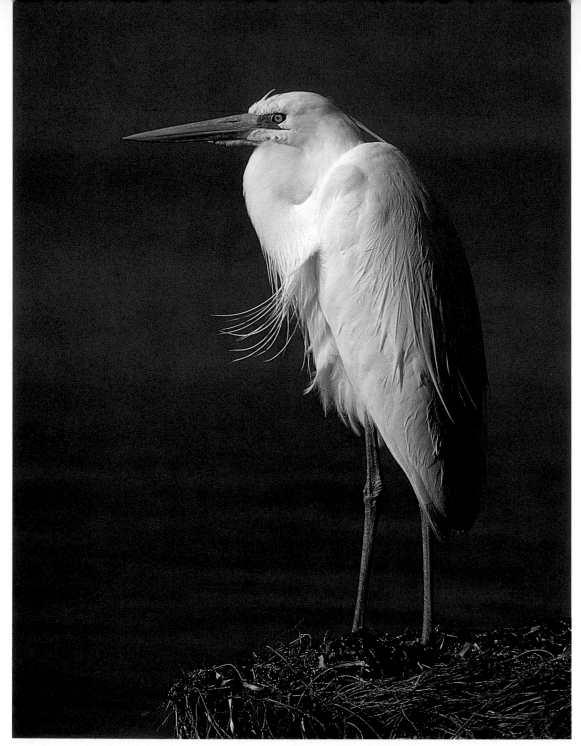

300mm lens with 1.4X multiplier, 64-speed film, 250th of a second, f/11.
Behind a coin laundry, waiting for the dryer to finish its spin—it wasn't exactly the Serengeti.
But that's where I found this great white heron and managed a portrait that says as much about
herons as any I've taken or seen.

Recording "Suchness"

I got this great white heron photo during a two-week stay in the Everglades. The night before, I experienced some sort of cerebral breakdown and didn't close one corner of my tent flap very well. A hard thunderstorm in the night brought me a wet sleeping bag. So my friend and I headed for the nearest coin laundry that morning to dry my gear. While the machine tumbled and fluffed, we wandered behind the building to Florida Bay. There we found this incredibly approachable heron. We were able to photograph it easily by stalking. I used a 300mm lens with a 1.4X multiplier to give me more distance and a narrower field, but I could have used something much shorter and moved closer. It was a windy day, the breezes catching the bird's plumes. While we waited the overcast sky began to break, and the sun hit our bird. I metered off the beautiful white plumage and opened up two stops to give me detail and nice contrast between the bird and the water. For me, the resulting image says "heron."

What I aimed for in this photograph is what artists of the Orient call "trueness to nature." This doesn't mean that a work of art has to be super realistic but that if you're making a picture of a heron, you should reveal something of its "heron-ness." You should show its distinct bird nature in the picture. The logic goes that if you make a picture of a bird in a field of bam-

400mm lens, 100-speed film, 125th of a second, f/5.6.
Sometimes a photograph's story is not only in the subject. It's the story of the subject in its environment. I photographed this female northern cardinal after a particularly rugged Michigan ice storm. It's a survival story, the most poignant story birds have to tell.

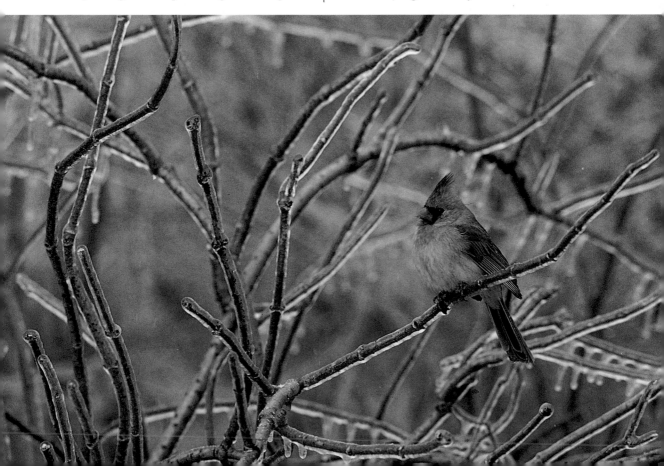

boo, the bamboo should reveal the nature of bamboo and the bird the nature of bird.

All of this applies easily to photographs. There are times when birds will show the essence of themselves—moments when the *suchness* of the bird comes through. That's what I'm trying to bring out in my photographs. That's what fuels my patience in the field. I want to make portraits of birds caught in the act of being birds.

Composition Primer

A female cardinal puffed up for warmth after a rugged ice storm. I wanted to allow the desolation and cold of the scene onto the film. And the best way to do that was to compose for it. I placed the bird on the right and gave plenty of space around her for the landscape to tell her story.

I could have chosen to photograph this bird up close and personal, dead center in the frame, with a smidgen of room at the top past her crest and a smidgen at the bottom past her tail. Then I'd have a picture of a big, puffed up bird. But I wouldn't have a picture of a cardinal surviving a rough winter.

I opted for the bird small in the frame, placing her at about the lower right third of the picture following a classic compositional rule. That rule, the rule of thirds, suggests that you mentally divide your photo area into a tick-tack-toe grid and place the main subject on one of the inside intersection points. A simpler

way of stating this is that placing the subject somewhere off-center is usually a good idea, because compositions tend to be stronger if the subject is not baldly in the center of the frame. A balanced composition is usually less dynamic than a composition with off-center framing, though at times you may want the peace and tranquillity, the quiet of a centered composition. It depends on what you're trying to achieve.

These are *your* photographs, and they should express what you want them to. So when you compose a photograph, really look at it. Try framing your subject in different ways, horizontally and vertically. Place yourself at different angles. Notice what sort of graphic pattern the landscape makes. What does the horizon add to the scene? What sorts of shapes are the trees making? For every photo, you'll start from scratch with these considerations. When you've fairly well settled on a composition, be sure to check all the edges of the frame. It's easy to keep your eye on the subject and not notice that you may have a power plant or a Buick sneaking into one corner of the frame.

Individual tastes vary, of course, but it's almost always true that a simpler composition is more successful. In my work, simplicity is key to my compositions. To say what I want to say, I need only what I need. Everything else is baggage. Keep your photographs simple. Keep them distinct.

AFTERWORD

Businessman, peacemaker, environmental defender, and friend, Gordon Sherman was founder of Business and Professional People for the Public Interest, a Chicago law firm established for the protection of social and environmental interests. He was also one of Larry's summer workshop participants. Gordon fought cancer for seven years. He died in 1987.

It was during his last few years that he decided to become a fine bird photographer. He achieved his goal and in the process wrote some of the most eloquent essays on the experience of bird photography that we've ever seen. We'd like to let Gordon close the book with this excerpt from "With One Eye Open" (*Birder's World*, November/December 1988).

There are moments, forever to remain inexplicable, when a certain harmony seems to descend upon the scene, some divine unity that briefly blends me into the habitat and lets me enter the forbidden sanctum of the animal world, not as a stealthy predator, but as an accepted individual among the species. I often long to know what control I might exert to bring this about at will, but whatever the cause, it is for me a state of grace, the tenderest interlude in my work. Then the pictures I came to get seem relegated to a subordinate place, mere mementos of a loveliness that only pure memory can recall.

RESOURCES

Magazines

Bird Magazines

Birder's World
44 E. 8th St.
Holland, MI 49423
616–396–5618

BirdWatchers' Digest
P.O. Box 110
Marietta, OH 45750–9977

Living Bird Quarterly
Cornell Laboratory of Ornithology
159 Sapsucker Woods Road
Ithaca, NY 14850
607–254–BIRD

Wildbird
3 Burroughs
Irvine, CA 92718

Photography Magazines

Nature Photographer
P.O. Box 2037
West Palm Beach, FL 33402
407–586–7332

Outdoor Photographer
12121 Wilshire Blvd., Suite 1220
Los Angeles, CA 90025–1175
310–820–1500

Outdoor Travel and Photography
1115 Broadway
New York, NY 10010

Popular Photography
1633 Broadway
New York, NY 10019

Books

Field Guides

Peterson Field Guides, Houghton Mifflin.

Field Guide to the Birds of North America, National Geographic Society, 1987.

Audubon Handbooks, John Farrand, Jr., McGraw-Hill, 1988.

Golden Guides, Golden Press.

Natural History

Stokes Nature Guides, Little, Brown and Company.

Birder's Handbook: A Field Guide to the Natural History of North American Birds, Ehrlich, Dobkin, and Wheye, Simon & Schuster, 1988.

Audubon Society *Encyclopedia of North American Birds*, John K. Terres, Borzoi Books, 1980.

Photography

*The Nature Photographer's Complete Guide
to Professional Field Techniques*, John Shaw,
Amphoto, 1984.

The Art of Bird Photography, Eric Hosking
and Cyril Newberry (out of print), Country
Life Limited, 1944.

Specialty Nature Photography Equipment

Mike Kirk Photography
RR #4 Box 158
Angola, IN 46703
219–665–3670

Wimberley Design
133 Bryarly Rd.
Winchester, VA 22603
703–667–9378

*Invisi*blind
Rod Planck Photography
5210 Hurbert
Spruce, MI 48762
517–727–3260

Leonard Rue Enterprises
138 Millbrook Rd.
Blairstown, NJ 07825
908–362–6616

BIBLIOGRAPHY

Articles

Bailey, Gerald. "Photographing at a Warbler Water Feature." *Wildbird*, July 1992.

Carlisle, Steve. "Birds in Flight." *Birder's World*, August 1992.

Carroll, Ron. "Remotes and Slaves." *Outdoor Photographer*, July 1987.

Foott, Jeff. "Ethical Photography: Sharing the National Parks." *Outdoor Photographer*, February 1989.

———. "On Ethics in Photography." *Outdoor Photographer*, November 1988.

Longest-Slaughter, Helen. "An Interview with Larry West." *Nature Photographer*, September/October 1991.

Peterson, B. "Moose." "Nature." *Popular Photography*, January 1992.

Picker, Fred. "Zone System Made Easy." *Outdoor Photographer*, September 1989.

Rowell, Galen. "The New Fill Shooters." *Outdoor Photographer*, May 1990.

Sammon, Rick. "Why Go AF?" *Outdoor Photographer*, May 1991.

Szafranski, Keith. "How to Build a Floating Blind." *Wildbird*, December 1991 and January 1992.

West, Larry. "Exposure-wise: De-mystifying Metering." *Birder's World*, July/August 1988.

———. "In Focus: Choosing Lenses for Bird Photography." *Birder's World*, November/December 1987.

———. "Lenses for Wildlife." *Audubon World*.

Books

Adams, Ansel. *The Camera*. Boston: Little, Brown and Company, 1980.

McDonald, Joe. *The Complete Guide to Wildlife Photography*. New York: Amphoto, 1992.

Minolta/Doubleday. *How to Use Your 35mm Camera*. A Modern Photo Guide. Valley Stream, New York: Avalon Communications, 1982.

Minolta Corporation. *Using Your 35mm Camera*. Garden City, New York: Doubleday & Company, 1982.

Shaw, John. *The Nature Photographer's Complete Guide to Professional Field Techniques*. New York: Amphoto, 1984.

Stokes, Donald W., and Lillian Q. Stokes. *A Guide to Bird Behavior*. A Stokes Nature Guide. Boston: Little, Brown and Company.